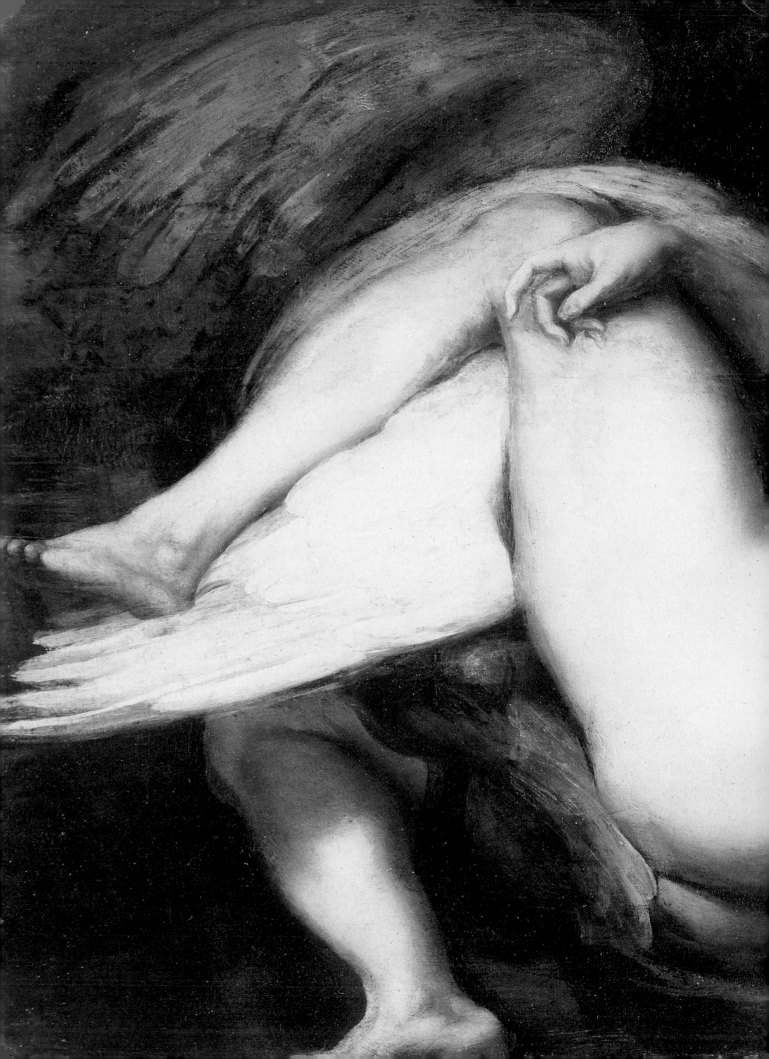

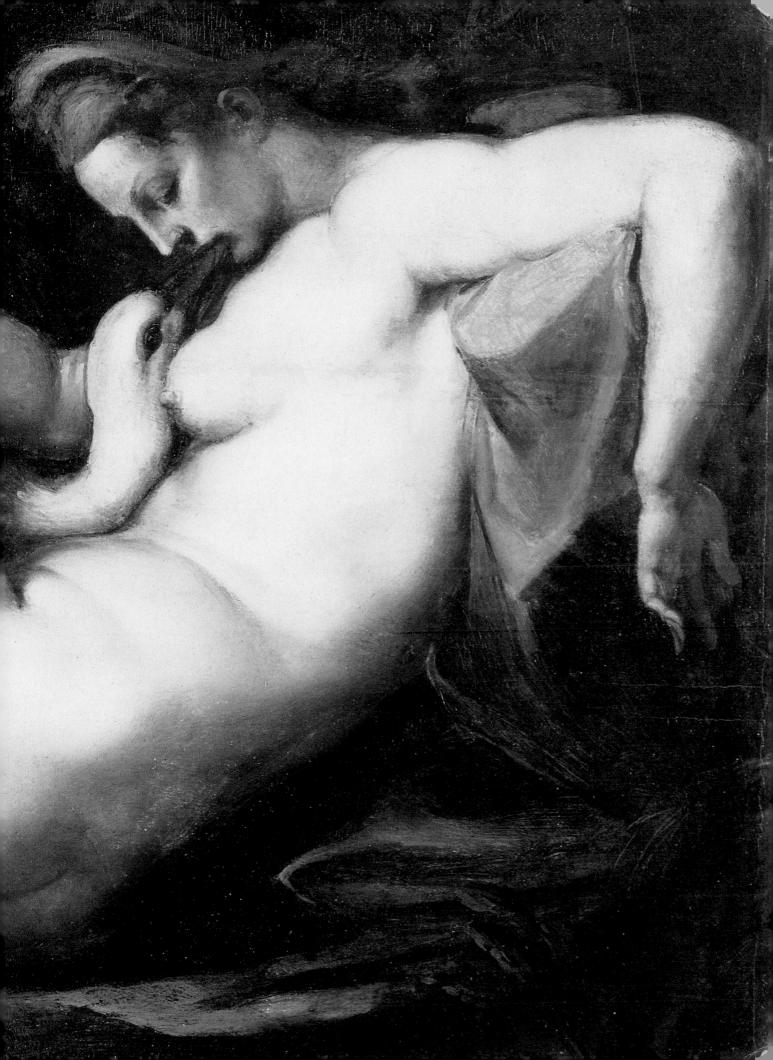

step by step art school
nudes

step by step art school
nudes

Jack Buchan and Jonathan Baker

hamlyn

First published in Great Britain in 1994 by Hamlyn,
a division of Octopus Publishing Group Ltd
2–4 Heron Quays, London E14 4JP
This edition published in 2001

Distributed in the United States and Canada by
Sterling Publishing Co., Inc.
387 Park Avenue South, New York, NY 10016-8810

ISBN 0 600 60448 9

A CIP catalogue record for this book is available
from the British Library

Printed and bound in China

Produced, designed and typeset by
Blackjacks
30 Windsor Road
London W5 5PD

For Blackjacks:
Artwork and demonstrations for:
Girl in the Bathroom, Laura on a Bed, Rupert, Female Body Builder & The Classic Female
Nude – Roy Ellsworth;
Girl Undressing, Boy on the Beach, Male Torso, Alice Playing, In the Shadows & Lydia
– Ian Sidaway
Photography by Paul Forrester and Laura Wickenden
Edited by Patricia Seligman

Credits
pp2-3 Christies Images; pp10-11 Christies Images; p12 *(left)* Staatliche Museu, Berlin-
Dahlem, *(right, top & bottom)* Christies Images; p13 *(left and right)* Christies Images; p14 *(top)*
Musée du Louvre, Paris, *(bottom)* Christies Images; p15 *(top)* Musée du Petit Palais, Paris,
(centre) Musée d'Orsay, Paris, *(bottom and right)* Christies Images; p16 *(left, top & bottom)*
Christies Images, *(right)* © Baroness Kizette de Lempicka-Foxhall, Houston; p17 *(top & right)*
© Lincoln Seligman, *(left)* Christies Images; p142-143 © Lincoln Seligman.

Every effort has been made to contact all copyright holders of illustrations used in this book.
If there are any omissions, we apologise in advance.

Contents

Chapter 1
Introduction

Depicting the nude has, and always will hold, a fascination for the artist who is rewarded with an infinite source of inspiration. As a subject, the human form presents the artist with the ultimate challenge and is therefore a vital part of all art education. A certain amount of knowledge of anatomy and how a body moves is required, otherwise you could end up with a very static and unnatural image. We cover this in chapter 2. However, as with everything in life, practice makes perfect and the rest of this book then concentrates on step-by-step projects which you can follow.

In this chapter we will look at a personal selection of some of the most important artists who have depicted the naked human form through the ages. These artists have all been innovators in their time and their very different interpretations of this common subject matter can be an inspiration to any artist. As you will see even when the morality of the times has not approved of nakedness, the ever-resourceful artist has always found a way around it. And, because of this, it is also possible to judge the morals and politics of an era through the paintings of the naked figure. We hope that the following pages will fire your imagination and lead you to your own experiments, whether they be realistic, showing all of natures defects, or a simple celebration of the naked human form.

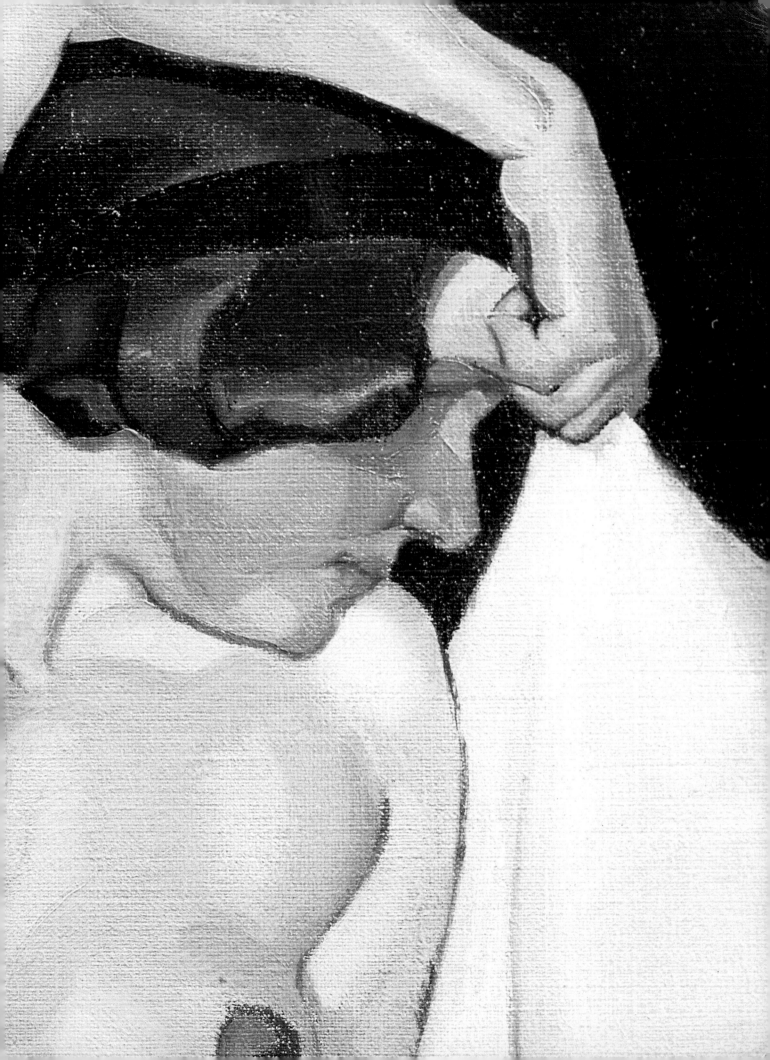

Introduction

HISTORY

It is impossible to date man's first depiction of the naked figure. But, just as we learn about everyday life from the early cave paintings, so we learn what our ancestors looked like and how they reacted to one another. These paintings may lack in sophistication but they show us that the naked body was considered perfectly natural and not something to be hidden. Unfortunately as man evolved and became more 'civilized', especially in the wake of Christianity, the naked body, for most people, was

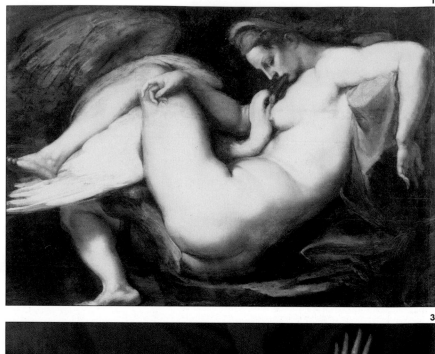

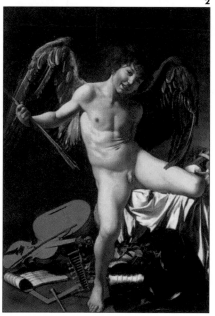

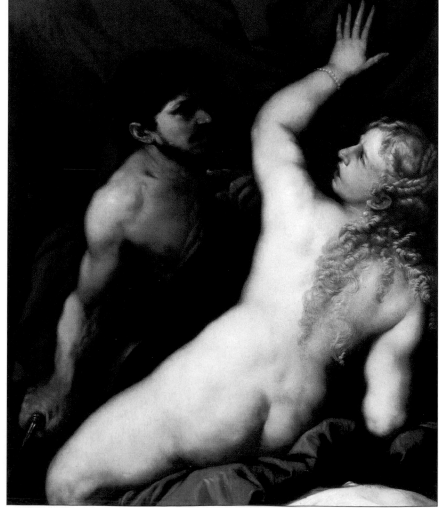

1 *Leda and the Swan.*
Peter Paul Rubens (1577-1640).

2 *Love Triumphant.*
Michelangelo da Caravaggio (1571-1610).

3 *Tarquin and Lucretia.*
Luca Giordano (1632-1705).

4 *The Bathers.* August Heinrich Riedel (1799-1883).

5 *A Nude With Raised Arms Seen From Behind.* Henry Fuseli (1741-1825).
A detail from one of the *Quirinal Dioscuri* is shown over pages 18 and 19.

12

considered something personal that was to be kept hidden.

One of the greatest sources of nude studies comes from the ancient Greeks who believed in the pure beauty of the human form. The painting and sculptures which have survived from this early civilisation have provided an important source of inspiration for artists ever since. Italian artists of the 15th century turned to these early masterpieces for information as well as inspiration. Indeed, during the Renaissance intellectuals studied not just the art but the whole philosophy of the ancient Greeks. From their principles about proportion and anatomy to scientific rules which govern the universe and how they are all inter-related. During this time lay – rather than church – patronage became fashionable which encouraged new subject matter where the nude was important, particularly in classical legends. Even so, many of the great nude works at this time were commissioned by the church, such as the Sistine Chapel by Michelangelo (1475-1564). The new thirst for knowledge of the human form led to research into anatomy. The most famous are by Leonardo da Vinci (1459-1519) whose studies of the human anatomy are a testament to his precise medical knowledge as well as his brilliant draughtsmanship.

With this mixture of interest in the human body and freedom from the church, the new patrons encouraged

4

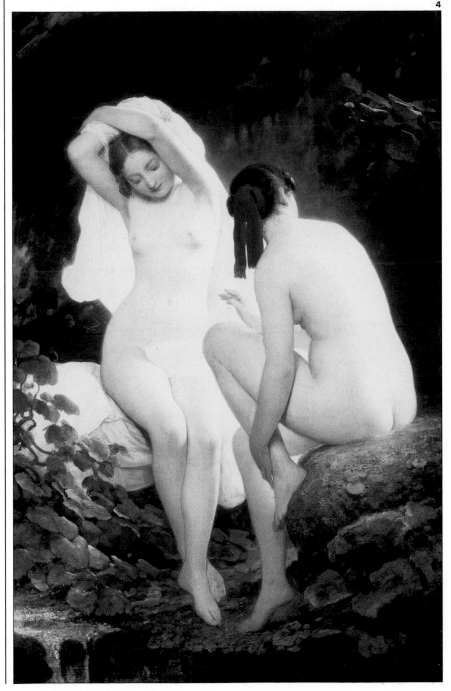

5

HISTORY

artists to paint erotic images with naked figures. They were disguised as scenes from ancient mythology such as those painted by Botticelli (1445-1510). But it was through the paintings of artists such as Titian (1487-1576), Giulio Romano (1492-1546), who produced a series of pornographic engravings and Correggio (1494-1534) that you can see that their work became a celebration of the sheer beauty of the naked human body.

This celebration continued through the centuries creating such masters as Bronzino (1503-1572), Tintoretto (1518-1594), Caravaggio (1571-1610), Rubens (1577-1640),

Rembrandt (1606-1669) – who entitled one of his works, 'The Anatomy of Dr Tulp' – Boucher (1703-1770), Géricault (1791-1824), Goya (1746-1828), Blake (1757-1827), Ingres (1780-1867) and Delacroix (1798-1863). Even as late as the 19th century a double standard existed in nude painting where they were only accepted by society if they were set in classical or mythological surroundings. A good example of this is 'Diana' by Renoir (1841-1919). The painting was originally a study of a naked female and was considered to be in bad taste, so he added a hunting bow, a deer at her feet and a discreetly placed animal skin so the

INTRODUCTION

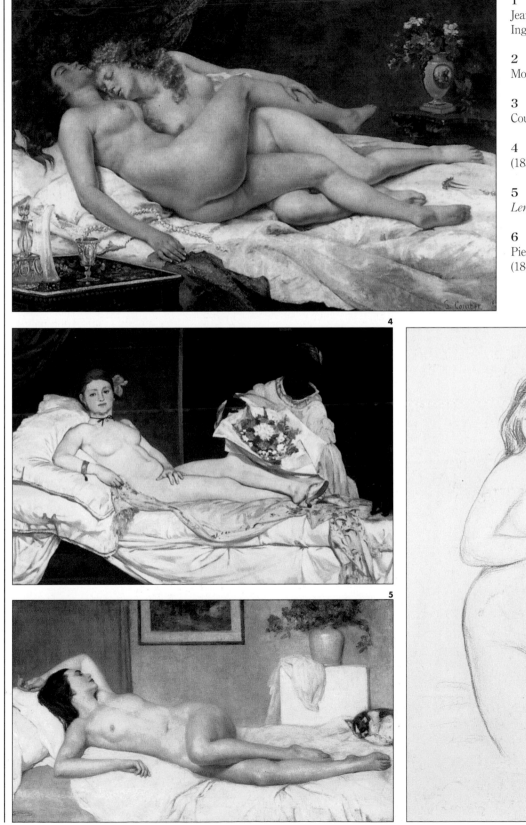

1 *The Turkish Bath.* Jean Auguste Dominique Ingres (1780-1867).

2 *Liegende Akt.* Kolomon Moser (1868-1919).

3 *The Sleepers.* Gustave Courbet (1819-1877).

4 *Olympia.* Edouard Manet (1832-1883).

5 *A Nude Reclining Full Length on a Bed.* Jean Cottenet.

6 *Jeune Femme se Baignant.* Pierra Auguste Renoir (1841-1919).

HISTORY

painting became 'Diana' and was considered a masterpiece! However he did go on and paint simple studies of the nude.

It was such hypocrisy that made the French Impressionists rebel. Take Manet (1832-1883), for instance, who caused an uproar when he showed his 'Déjeuner sur l'Herbe' in 1863 and later in 1865 with his painting 'Olympia'. Courbet (1819-1877) painted 'The Sleepers' in 1866 as a private commission for the former Turkish ambassador to St Petersburg, which depicted an image of lesbian love. Imagine the outcry if it had been exhibited publicly. We cannot leave the 19th century without mentioning Gauguin (1848-1903) for his studies of Tahitian women and Dégas (1834-1917) whose beautiful paintings of naked women set them in everyday surroundings, performing simple domestic tasks such as bathing, where

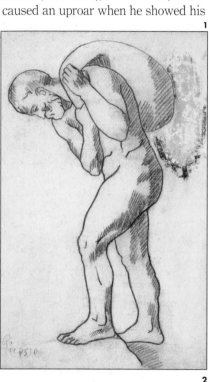

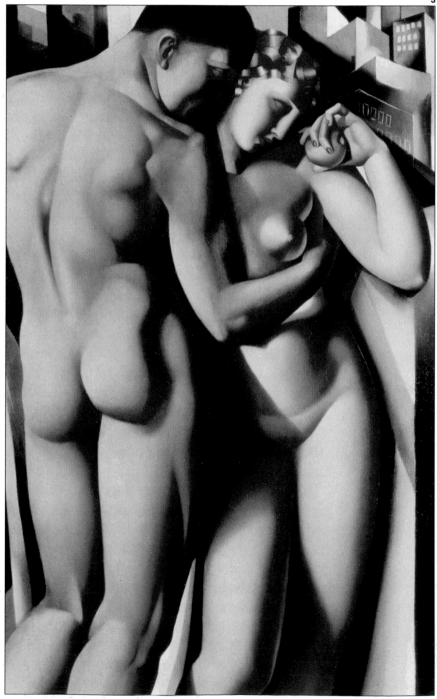

women would naturally have removed their clothes.

Luckily such social constraints no longer exist for the artist of the late 20th century. This gives you the freedom to concentrate and experiment with painting the nude without having to worry about criticism on moral grounds. This greater freedom has produced some of the most interesting depictions of the naked body from Picasso (1881-1973), Schiele (1890-1918) and Wesselman (1931-) to the more realistic and often harsh pieces of Stanley Spencer (1891-1959) and one of the great masters of this century, Lucien Freud (1922-).

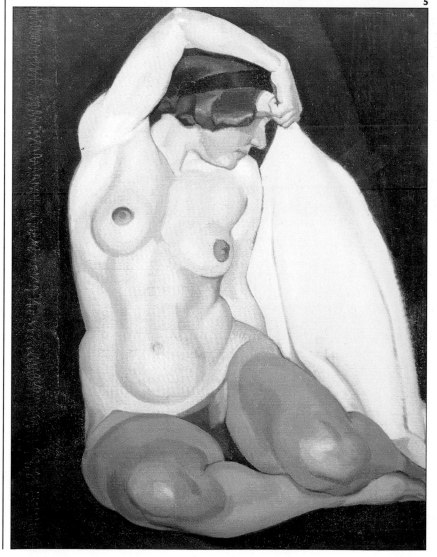

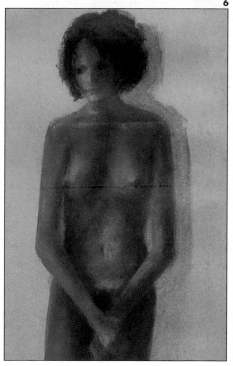

1 *Homme à la Besace*.
Pablo Picasso (1881-1973).

2 *Untitled*. Egon Schiele (1890-1918).

3 *Adam and Eve*.
Tamara de Lempicka (1898-1980).

4 *Blue Nude*. Lincoln Seligman.

5 *Nu Assis*. Rottmayer.

6 *Nude Study*. Lincoln Seligman.

Chapter 2
Where to Start

In this chapter we explore the basic principles that are useful to the artist when depicting the human figure; anatomy, the perspective of the body, balance, and so on. However, no matter how many 'rules' and 'secrets' we show you, success with drawing and painting the nude will depend to a great extent on careful observation of your subject.

It is familiarity which is the main culprit. Because we see other humans every day – albeit not normally naked – we tend to have pre-conceived ideas of what the body looks like, especially with regard to colouring, proportion and size. Even if you learn what the 'ideal' figure should look like and exactly how it works, if you do not capture the individuality of your model then the drawing or painting cannot be regarded as a success. You must practise being objective, even with people you know very well, and try to keep your approach as fresh as possible.

Before we get properly started, just a quick note concerning compassion for your model. Even a professional model will need a five or ten minute rest every half an hour – even more often with a difficult pose – so if you have persuaded your next-door neighbour to pose for you, remember their feelings and let them rest often. In addition, you will not be popular if the room is chilly so, unless you live in the hottest of climates, make sure the heating is turned up to full.

Where to Start

ANATOMY

A working knowledge of human anatomy is evidently useful for any artist attempting to portray the nude. But, although extensive studies of anatomy carried out during the Renaissance, like those of Leonardo da Vinci (1452-1519) and Michelangelo (1475-1564), revolutionised the way the human figure was depicted, an understanding of anatomy will not, in itself, lead to a wonderful finished work of art. After all how many surgeons do you know who are famous painters?

None the less, anatomical drawings can be very useful in showing you how the internal structure of the body works, especially the skeleton and muscles. A medical student would be interested in these areas for their own sake, but for you, the artist, they are a means to an end. This internal structure underlies the surface shape and dictates the positions the body can move through. Everyone has a unique surface appearance, but their bodies all function in the same way.

Skeleton

The skeleton provides the body's basic structure and support, as well as supplying protection for many of the internal organs. The word 'skeleton' comes from the Greek 'dried up', but this description is not accurate since living bone is constantly renewing itself. The adult human skeleton consists of 206 bones (you are born with 350 but many join together as you grow) which fit together using a number of different types of joint. The body has three main masses; the head, the ribcage and the pelvis, which are linked together by the spine.

The spine (or vertebral column) is made up of alternate discs of bone and cartilage which, not only give support for the weight of the torso, but also determine the limits of flexibility and movement of the various elements of the body. The spine starts out as a 'C' shape in the foetus, but after birth the raising of the head soon creates a backwards curve at the top. Standing and walking then take their toll, and the bottom section of the spine starts to bend towards the front of the body. This creates the 'S' shape which you normally associate with the spine. When drawing

or painting the nude it is always advisable to pay particular attention to this curvature of the spine since the whole essence of the skeleton is reflected in it.

Muscles

Linking and complementing the skeleton is the muscular system. All your body's movements (baring those caused by gravity) are caused by the contraction or relaxation of one or more muscles. Muscles cannot push, and in fact the action of pushing something away or pushing against an object is really created by muscles pulling against certain joints.

Most of the muscles in the body are concerned with moving the skeleton and are normally attached to two different bones. One bone will move more easily than the other so, as the muscle contracts, a simple movement will be created. By working in groups a huge range of actions become possible. Certain categories of muscles also exist; flexors, for instance, bend limbs, while extensors straighten them.

The muscles perform a number of other functions such as circulating blood and protecting the visceral organs, but for the artist the real interest is how they affect the surface shape of the body. If you know where the main muscles lie and in which direction they pull, you will find the process of turning a live figure into a drawing or painting that much easier. In addition, it is important to remember that muscles tend to be more evident if the model is performing some activity, and in people with a large amount of body fat they may not be visible at all. Age also plays a pivotal role, with children normally having little or no muscular definition. At the other end of the scale, the wrinkled skin of very old sitters will vastly alter the way the body looks even though sinewy muscles may be apparent.

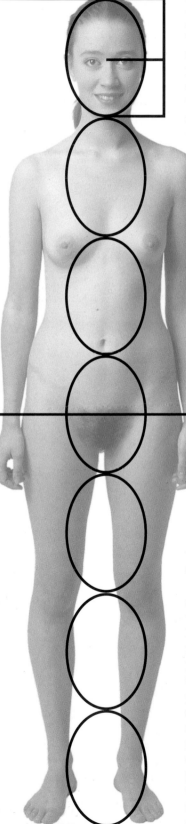

Proportion

Although we would stress that you should try and trust your own eye when depicting a nude, some basic knowledge of proportion will prove useful – even if it only allows you to plan whether the figure will fit on to your paper or canvas. In reality, most beginners tend to make the top half of their figures too large in relation to the bottom, with the head in particular often excessively big. This is because the top half of the body in general and the head in particular are given much more attention than the rest of the body and so become exaggerated in the viewer's mind. An extreme example of this is in the drawings of very young children where invariably people are little more than heads with hands sticking out.

Just as no two people look the same, no two people have exactly the same proportions. However, the *average* human figure can be quantified. The illustration on the left shows how the basic proportions of the figure are fractions of the whole. The head is roughly one-seventh of the total height of the figure, and the legs up to the pubis are about one-half. Further 'rules' can be made, such as the eyes are approximately half way down the head and the elbows are in line with the waist, but you can take things to extremes.

These measurements must be kept as a guide only, since nearly everyone will vary slightly in one way or another. However, if your study does differ wildly from these proportions, it is worth checking your work very carefully. It may prove that you have depicted your model perfectly (call the police at once, they are obviously an alien in disguise), but it is more likely that, in concentrating on one part of your figure, you have neglected the correct proportions of another. Use your pencil, held at arm's length with your thumb marking off the depth of the head, to check the proportions of your model against your drawing.

BALANCE AND MOVEMENT

Because of the infinite play between the skeleton and muscles, the body can fall in to a limitless variety of poses. Due to the forces of gravity everyone subconsciously alters their posture in order to keep their centre of gravity central to their body. By doing this, the least effort is used in keeping upright.

In a standing figure the centre of balance can be measured down from the clavicle which is the point between the collarbones at the bottom of the neck. When a person stands with their weight on one foot, the centre of balance runs from the clavicle through to the arch of the foot taking the weight (figure 1). If the body's weight is evenly spread between both feet then the centre of balance will fall between them, even if the body twists (figures 2 & 3). Once a person leans

FIGURE 1

FIGURE 2

FIGURE 3

forwards or backwards or to one side, the centre of balance becomes harder to establish (figures 4, 5 & 6). The hips are used as a counterbalance. If the shoulders are leaning to one side then the hips will lean the opposite way.

The best way to get used to the flow of balance through the body is first to practise

with matchstick sketches. Get your model to run through a few simple poses (like the ones shown here) and try to break the figure down to a few simple lines to denote limbs, torso and the head. Then analyze the position of the head and shoulders in relation to the hips and feet by drawing a vertical line through the figure.

FIGURE 5

FIGURE 4

FIGURE 6

FORESHORTENING

Foreshortening is one of the most common pitfalls for the beginner. By the principles of foreshortening, objects closer to your eye appear larger than those further away. Again, careful observation of your subject *should* lead to a perfect picture, but there are some steps you can take to minimise any chance of mistake.

When you first start out, try to concentrate on poses that play down the effects of foreshortening – where all the main parts of the body are at the same distance from your viewpoint – as there is no point in making things unnecessarily hard for yourself. You will find it easier if you work at a distance from your model so that you can see the entire figure at a glance.

Once you have completed a number of nudes successfully, you will inevitably want to progress on to some harder poses, but take these gently. Invariably these involve foreshortening. However, as is evident from the series of photographs here, as the foreshortening becomes more extreme, the problems get more difficult to overcome. Everyone has their own pre-conceived idea of what the human body should look like. A photograph from an unfamiliar angle looks odd, but is accepted by the brain because it is a photograph and therefore must be telling the truth. Do a painting from the same angle and you can be into real problems. If your painting is in any way wrong, it will look awful – and in truth, with some extreme angles even a perfectly captured pose will still look 'wrong'. What can you do to overcome this problem? In truth, not a great deal except a *lot* of practice.

A good place to start is by overcoming the prejudices of your own mind with regard to fore-shortening. This can be done by working from photographic reference. Since the pose is captured and already converted to a flat, 2D plane, your brain does not have the chance to pre-judge the situation. Therefore you can concentrate on depicting the subject accurately. Taken a stage further, there is nothing to stop you from scaling up from a photograph by using a grid and then painting on top of the resulting pencil outline.

If you really do want to throw yourself in at the deep end and work on extreme foreshortening from life, what you should do is opt for the traditional method of measuring the various elements in your composition with a pencil held at arm's length as described at the end of page 21. This may sound absurd in today's technologically advanced society, but it really is the best way!

FIGURE 1

These four illustrations demonstrate the effects of foreshortening. Figure 1 presents a difficult enough pose to capture accurately, but, as the viewpoint gets lower the foreshortening of the figure becomes more extreme (figures 2 & 3) and so the artist's job becomes harder. Figure 4 would have presented an almost impossible pose to depict, but by simply stepping to one side the effects of foreshortening are largely negated.

FIGURE 2

FIGURE 3

FIGURE 4

Chapter 3
Without Colour

Tonal drawing in monochrome is a fundamental skill that would greatly benefit any budding artist. Without the insight that producing a picture in 'black and white' gives you – especially with regard to how tone can be built up – it is much harder to be successful when working in colour.

Every artist's most precious possession should be their sketch book – the equivalent of a visual diary – where you can rough out ideas and refer back for inspiration. Obviously a 'sketch' requires a quick medium, and you cannot get much quicker than a dry, monochrome medium.

There are many different media which can be used for drawing, and all are challenging yet fun in their own way. In this chapter we focus on just two, graphite and charcoal but, once you feel confident with these, you will no doubt want to experiment with many others.

Graphite pencils are what everyone always associates with drawing. Although the simplest of drawing tools, they are remarkably versatile. We cheat slightly and make use of graphite sticks since they produce such bold marks, but the graphite projects will work perfectly well with an ordinary 'lead' pencil.

Charcoal sticks are perfect for the beginner as they are bold and very responsive to use. There is no messing around as you simply pick up a stick and start to sketch.

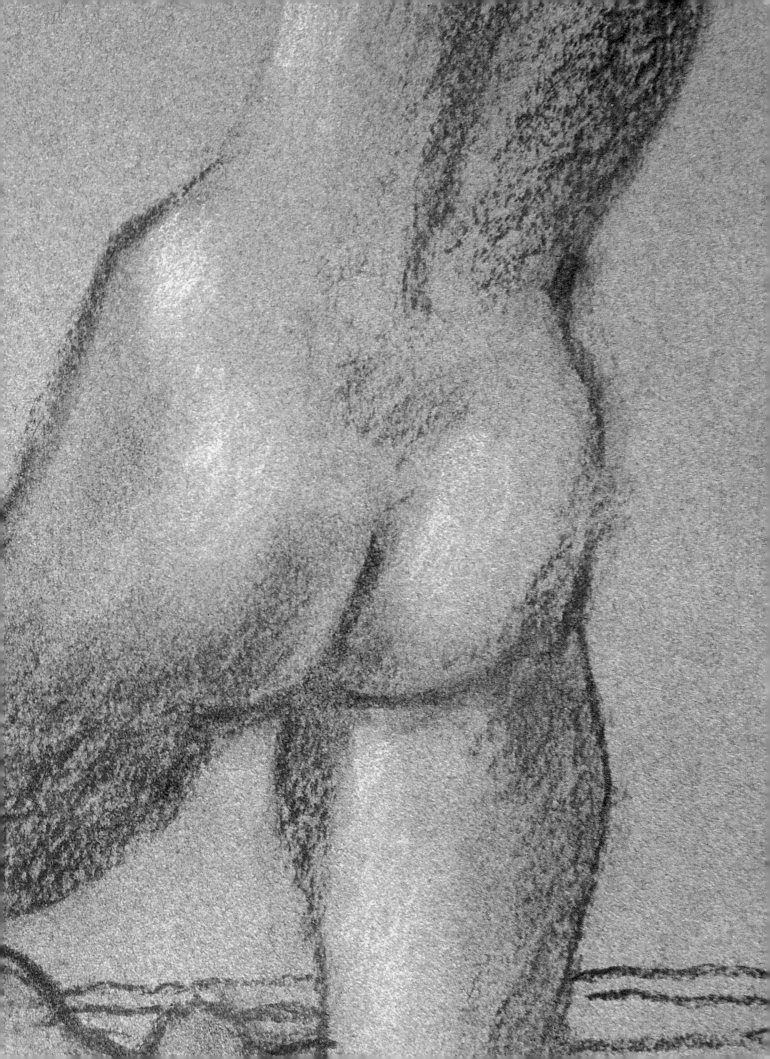

Materials

GRAPHITE AND CHARCOAL

Graphite

Graphite pencils (also known as 'lead' pencils) are the most common and least expensive drawing tools around, and are basically a thin rod of graphite encased in a hollow tube of wood. They are graded from 8H (the hardest) to 8B (the softest), but the marks they make vary greatly according to the paper used. Normally the best drawings would combine many different grades, each exploiting the paper with their individual qualities.

Clutch pencils and propelling pencils are also available. These can be extended as necessary and so avoid the need for constant sharpening while you draw. Graphite sticks are used in a similar way to charcoal, and their butter-soft texture makes them great fun for large, bold drawings.

Other Equipment

It is always handy to have a good stock of papers so that you can choose the one most suitable for a particular drawing. Use a craft knife or a safety blade for sharpening pencils; inexpensive sharpeners are less than ideal as they tend to break the lead. For erasing, kneadable putty erasers are cleaner in use than Indian or pink pearl erasers.

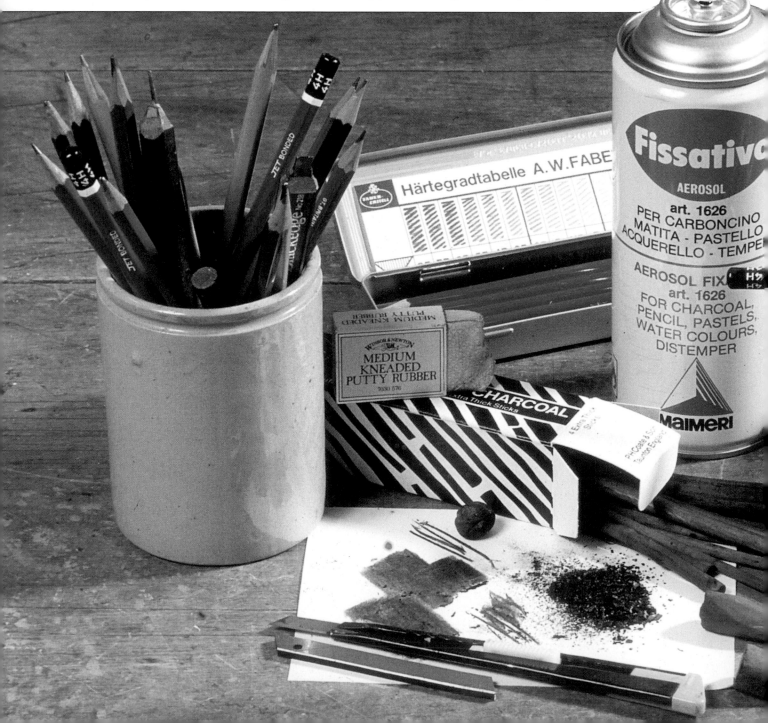

Charcoal

Charcoal is the oldest drawing medium, dating from prehistoric times. Today, charcoal is made from carbonized vine or willow twigs and is sold in sticks of varying thicknesses and degrees of hardness. The softer, more powdery type of charcoal blends and smudges easily and is good for broad tonal areas; the harder sticks are best for linear details. Charcoal pencils are made from sticks of compressed charcoal encased in wood. Although much cleaner to use, you do tend to lose the 'feel' of working with traditional charcoal sticks since you can only use the point and not the side of the stick.

Other Equipment

Charcoal works well on papers with a matte, textured surface, such as Canson, Ingres or the less expensive sugar paper. As charcoal smudges easily your finished drawings should be sprayed with fixative, which binds the charcoal particles to the paper surface. If you want to sharpen the point of a charcoal stick, use a scalpel blade or a piece of sandpaper. A kneadable putty eraser is useful for creating highlights in dark areas as well as for rubbing out mistakes.

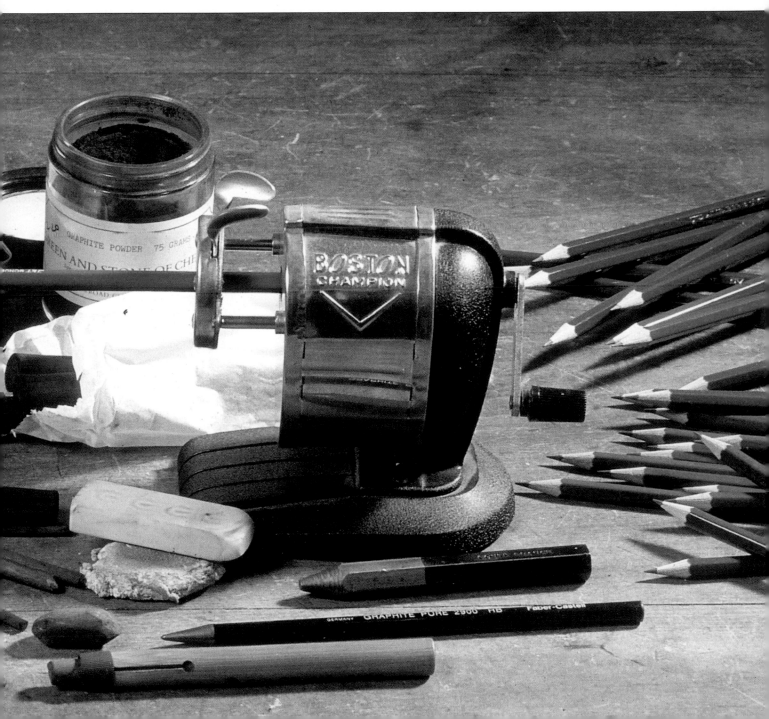

Techniques

GRAPHITE

Hatching

Solid tone and colour can be suggested in graphite using a series of parallel lines knows as hatching. This is perhaps the most basic drawing technique, and the one which most people would start to use naturally before moving on to others. By varying the weight and density of the hatched lines, a tonal variation from light to dark can be achieved easily and quickly. Straight, even lines produce a graphic effect while scribbled lines give a looser, more sketchy look. Different grades of graphite pencil and clutch pencil will give markedly different results. Graphite sticks, however, are only available in a few different 'B' grades, and consequently their marks tend to be rather similar. With the softer grades a hatched area can be lightly blended with the fingertip to produce textural variety. Hatched lines need not be straight; they can curve to follow the contours of an object, emphasizing its form.

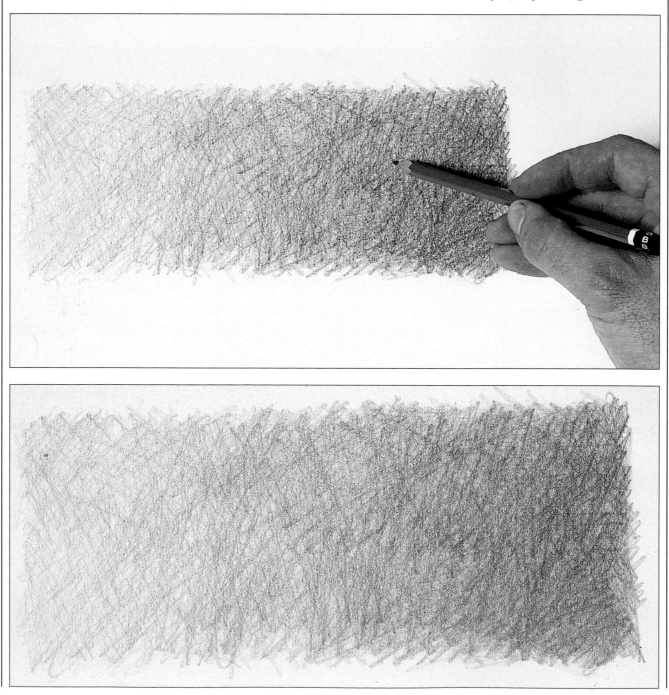

Crosshatching

This is a development of hatching, in which two or more sets of parallel lines are combined, one set crossing the other at an angle. Although originally developed for engraving, this technique can be used with all types of linear media, and some very interesting results can be achieved if you are prepared to experiment. As with hatching, graduations of tone can be achieved by varying the density of the lines: the more closely spaced, the darker the tone. The lines can be crosshatched at any angle you like, and even curved. Generally, freely drawn lines look more lively than perfectly straight ones.

In theory an entire drawing can be produced using crosshatching, but it is a labour-intensive technique. More often it is used in small areas of a drawing, its crisp, linear effect providing a textural contrast with the softer lines and shading used elsewhere.

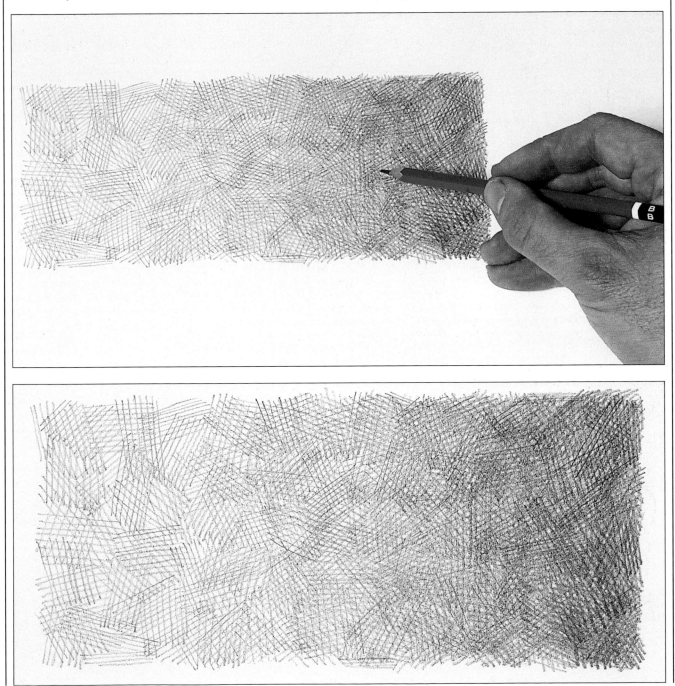

CHARCOAL

The beauty of charcoal is that it is so simple to use and it has a speed and spontaneity which lends itself to expressive drawing. It is the perfect medium for beginners and is nearly always the first medium introduced in art schools because it encourages students to think about the whole subject rather than getting lost in detail. Experiment with lines, varying the pressure to produce different thicknesses. Using the side of the stick gives a broad band which picks up the surface texture of the paper. The tip gives a solid black line with a smooth, flowing quality. For really fine lines, a sharp point can be obtained by lightly rubbing the end of the charcoal on a piece of sandpaper.

Tone

The most useful technique – as well as the most common – when using charcoal is to build up tone with a series of loose strokes (hatching). Draw yourself a small rectangle – which is purely to give yourself a restricted area when practising – and then start to fill it in slowly with loose, gentle strokes starting from one corner and finishing in the opposite corner. For darker tones you can work over from one corner again and again with the same loose strokes. Here it has been done twice to show how different the effect is between using *(1)* willow charcoal and *(2)* compressed charcoal, which is produced from charcoal powder pressed with a binding medium.

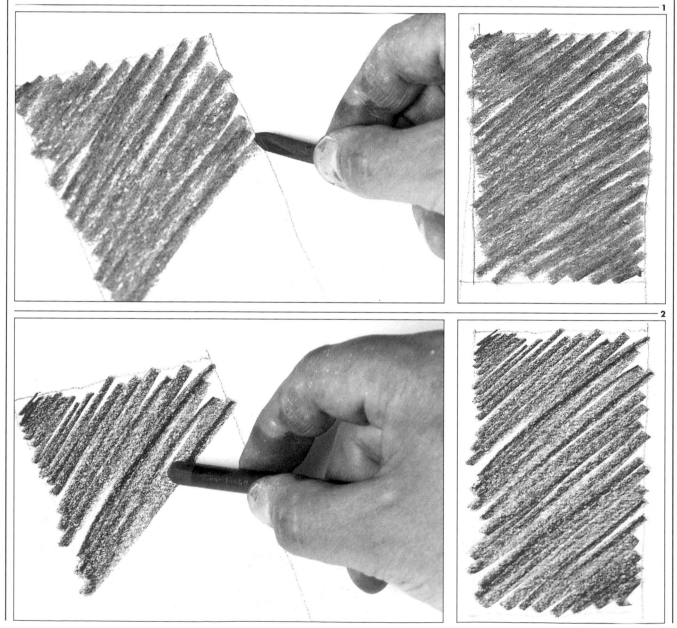

Soft Blending

The fact that charcoal is such a soft medium means that you can blend it with your finger to create a smooth, velvety effect. Again draw a small rectangle and then fill in one side with fairly solid black using the side of the stick for speed. Then, with the tip of your finger, gently rub the charcoal to form a graded tone which has a lovely smooth finish. You can lighten the tone with further blending, or darken it by going over the area again with more charcoal and repeating the process.

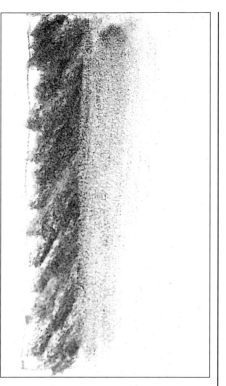

Highlights

To pick out highlights in a toned area you can use either a kneadable putty eraser or a stick of white chalk. Draw a small rectangle with the tip of the stick, and lay a fairly solid area of charcoal. Break off a small piece of the eraser and knead it with your fingers until it is warm enough to mould into any shape. To pick out highlights, pinch the putty to a fine point and use a press-and-lift motion without rubbing. To smudge or subdue the tone, rub gently with a round ball of putty. The putty can also be pulled across the charcoal – as shown here – to give a band of light through dark *(1)*. When the putty becomes clogged with charcoal, discard it and break off another piece. An alternative to this is to use a stick of white chalk *(2)* and pull it down the paper in the same way. The real difference with chalk is that the highlights will be much sharper and a purer white.

1

2

Girl Undressing

GRAPHITE STICK

For this initial project we look at how to work quickly and spontaneously from life. The three sketches that follow were all done in under ten minutes. Detail is kept to a minimum, instead emphasis is put on capturing the pose with as few marks as possible. This style of working is perfect for the beginner because it helps you to explore the main lines of the human body with a relaxed, fluid line without worrying about details. In half an hour you could easily run through five or six different poses, which will improve your perception of the human form remarkably. At the second or third sketch you will already know which are the most important areas to get right for the drawing to work.

Instead of using a graphite pencil, the artist in this case used a 4B graphite stick. These are wonderful for this style of outline sketch because they produce a good soft, dark line – reminiscent of charcoal but with a smoother texture typical of graphite. Obviously, if you feel more at home with ordinary pencils, then there is no reason why you shouldn't use them for these projects, but it is always worth experimenting.

We will talk you through these sketches as if you were doing them – and indeed you could sketch from the photographic reference shown here. But you will benefit more from working with a real model. Only then will you get a true feeling for what you are doing.

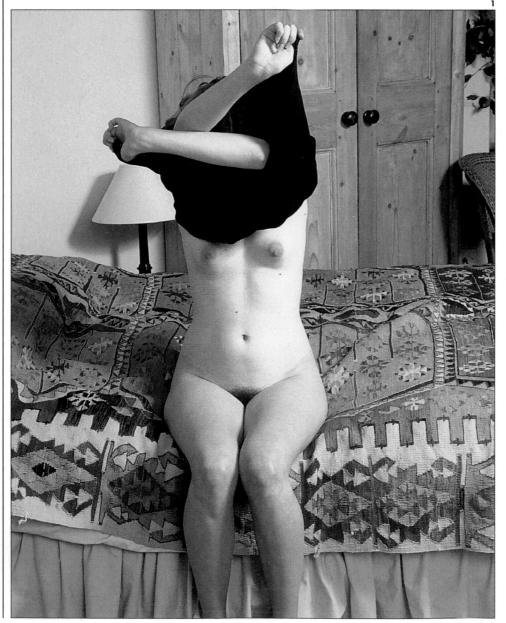

1

1 For the first sketch, get your model to pose with a dark t-shirt pulled up as if they are about to remove it. Note how the arms are positioned so that the forearms cross above the head and t-shirt. Even once you break the pose down into simple lines and blocks of tone you will find it a challenge. But, the more you practise, the easier it will become.

2 There is no rigid right or wrong way to start, only what works best for you. In this case the artist concentrates on the play of the arms and t-shirt and so decides to start at the top and work down.

Lay in the general outline of the arms and t-shirt before moving down to the torso. Try to restrict yourself to bold, spontaneous lines and do not attempt to put in any detail.

2

3

4

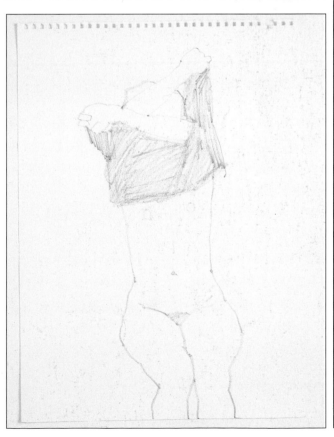

3 By the time the artist gets to the base of the torso, it has become apparent that the model's body will not fit on the pad. This will often happen when you work quickly. But, as the important part of the sketch is in place, it does not matter.

Continue working down the body, past the hips and onto the legs, at the same time dotting in the main features of the body such as the navel.

4 Finally, to finish the sketch, hatch some loose, parallel lines to block in the dark mass of the t-shirt. Again, keep your marks as relaxed and spontaneous as possible and definitely do not try to fill in the area with solid black. This would be too over-powering for such a simple sketch.

5

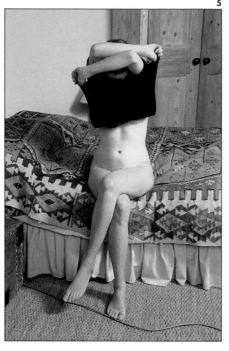

5 The previous sketch was totally posed, so this time get your model to run through a natural action and tell them to stop at a particular moment. You will see the difference if you ask your model to remove the t-shirt, telling them to stop when the pose is similar to the first one. To help you pick your moment you could get the model to perform the action as if in slow motion.

6 As with the first project start at the top of your paper and work down capturing the outline with bold marks. Keep the graphite stick moving with clear, fluid lines. Try not to hesitate or repeat a line if it does not work the first time. However, if you do go horribly wrong you can always use an eraser, but you should make every effort to keep this 'bad' habit to an absolute minimum.

6

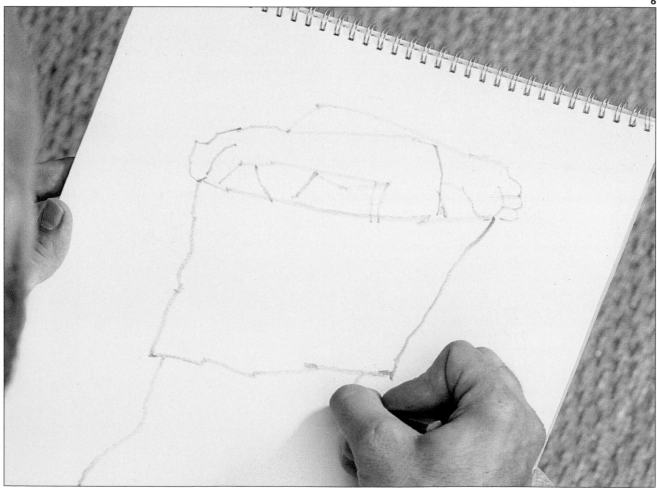

7 Continue by working down the figure – again, not worrying if it does not fit on the page – and then return to add in a suggestion of the details. Do not worry if your model has to move a bit to keep comfortable since any small shifts in position will not be reflected in the drawing. If a certain part of the pose is vital you can always direct your model back into the original position.

Once again, the drawing is completed by roughly hatching in the dark area of the t-shirt.

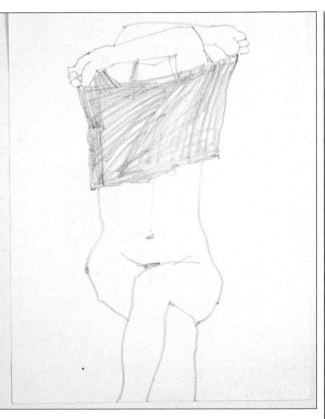

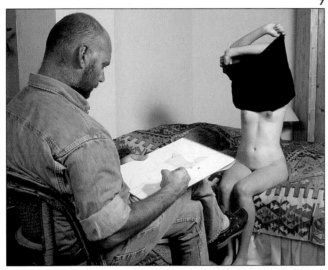

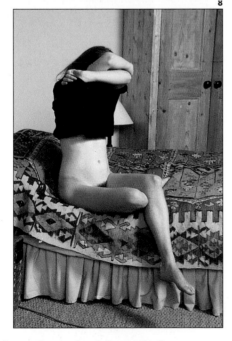

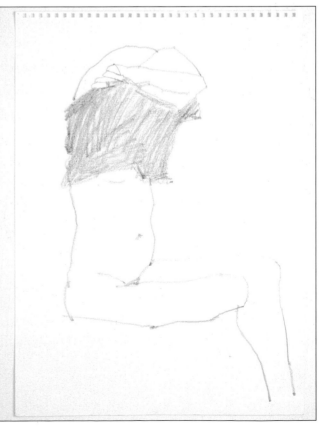

8 As a final variation on the theme, arrange your model in a similar pose once more, but this time get them to turn slightly in one direction. Then you can execute another quick sketch in exactly the same manner as before – starting at the top and working down – but this time you will be looking at the model from a different angle.

Boy on the Beach

GRAPHITE STICK

This step-by-step project is in many respects a continuation of the previous exercise. Once more a large graphite stick is used to create bold, expressive outline sketches. The difference here is that instead of having a live model the artist used a series of photographs he took while on holiday. This is a totally different way of working. Rather than having to sketch at break-neck speed while your model holds a pose, with this approach you can choose to plan the drawing carefully and work at your own pace. The real trick is to maintain the feeling of spontaneity. A skilled artist can make even a tracing look spontaneous, but for the rest of us mere mortals the trick is harder to master. Study the reference shots below and try to identify the main forms before you start. Make an effort to work out which lines are important before you even pick up your pencil or graphite stick.

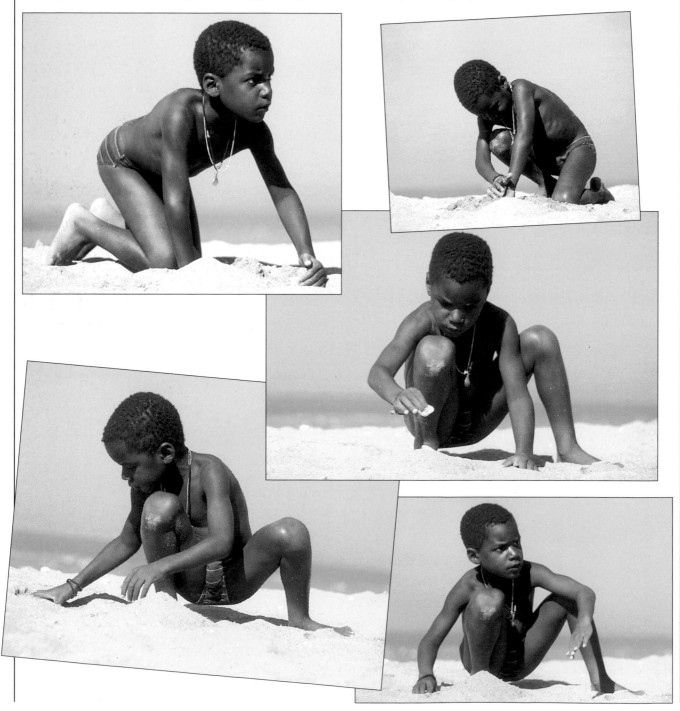

1 Select a large sheet of paper that will easily hold all five sketches. Try to imagine all the finished sketches on the sheet so that you can decide where to start and how big each one should be. As we mentioned in the previous project, where you actually start each sketch is a matter for personal taste but in this case the artist started with the boy's head each time. This is because the head – in particular the face – is the first place that people instinctively look.

Therefore, if you get the head correct half the battle is won.

2 As you finish one sketch move straight on to the next. Work in a circular direction around the paper so that all the sketches remain grouped and do not worry too much if they overlap. Notice how the artist is putting a lot of pressure on the graphite stick to make his marks bold and cutting. Little attention is being paid to detail, instead the form is captured in a simple, definitive outline.

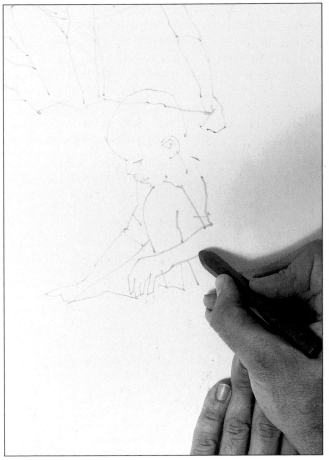

3 You should find that with each sketch it seems easier to capture the flow of the contours and, in a matter of minutes, the project is completed. Note how the circular layout carries the eye around the paper from one sketch to the next. Individually these sketches would be rather plain, but as a group they seem to take on an unexpected vitality. And, although the project was carefully planned, the bold, decisive stokes do in fact give a spontaneous feel.

Outline sketching is an extremely good way of getting used to drawing the human body. All your attention is focused on capturing the form with an economy of line. In addition, these types of sketches make the perfect starting point for a painting in virtually any medium.

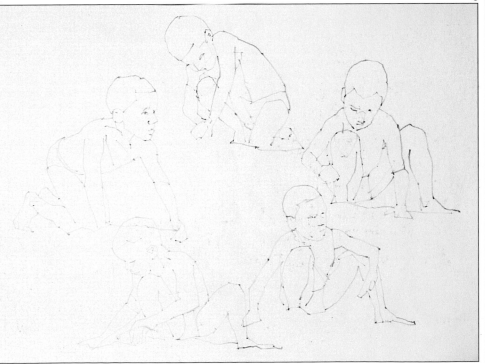

Girl in the Bathroom

CHARCOAL

This pose would be practically impossible to hold for any length of time. Not only that, but bathrooms are not exactly the largest or warmest places in the house, making it a tight squeeze for an artist and model to work in. So what you need to do in a situation like this is to take a photograph and work from that.

Although there are several interesting details in this composition, such as the taps and baskets, never forget that the real focus of this drawing is the figure, and that is where to start. Once you have worked up the figure, you can then decide how much detail you want to include. Another point is that charcoal does not lend itself to intricate details so you need to suggest detail with a few well-chosen lines.

The choice of this image for a charcoal drawing was influenced by the already fairly monochromatic distribution of colour. Your choice of paper colour will also play an important part in the finished image as the tint will inevitably play an integral role, adding harmony to the finished result.

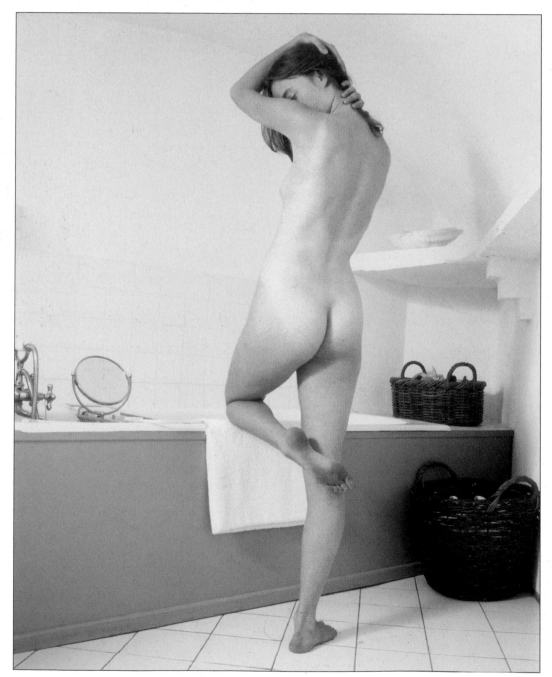

1

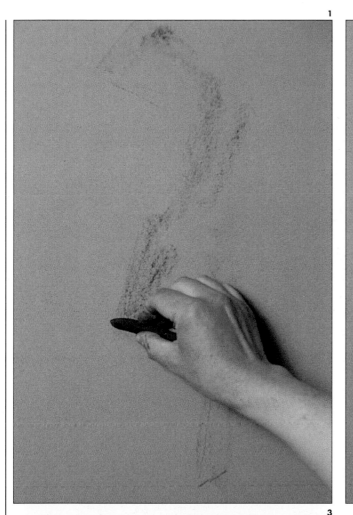

3

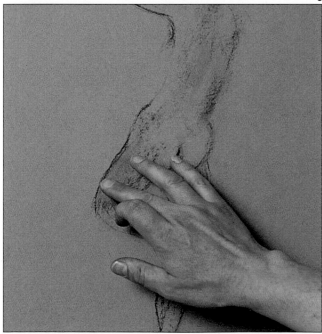

1 On a sheet of grey Ingres paper and with a single stick of willow charcoal start to sketch in the figure with the side of the charcoal stick. You will find these willow sticks very fragile which will encourage you to hold them gently, which will, in turn, produce a more fluid stroke.

2 As you can see from this picture, change now to the point of the charcoal stick, which will produce a sharper line, and start to describe and define the alternate curves of the torso and the legs. When you have done this you can then model the figure as a whole with the softer stroke made with the side of the stick, adding detail with the point.

3 Now for the messy part! Rub your finger lightly over the darker areas of tone around the back, pelvis and legs, smoothing out the marks and softening the tone.

4 With light strokes, and using the pointed end of the charcoal, go over the areas that you have just smudged, to redefine details and make them stand out again. Moving over to the shoulder, and still with the pointed end of the stick, start on the side of the face and the hair.

5 Continue to work on the upper part of the body with the pointed end of the charcoal and complete the arm and hand. Smudge the underneath of the arm slightly before reinstating it to keep the lines soft and indistinct. Now continue by working up the features of the face and the fall of the hair.

To do this employ the same technique of gently smudging and then reinstating to keep that soft overall feel. At this point fix the whole work so that crisper marks can be made over the top and to stop accidental smudging.

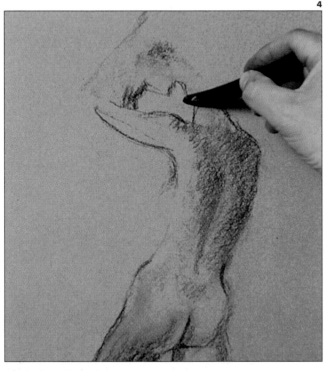

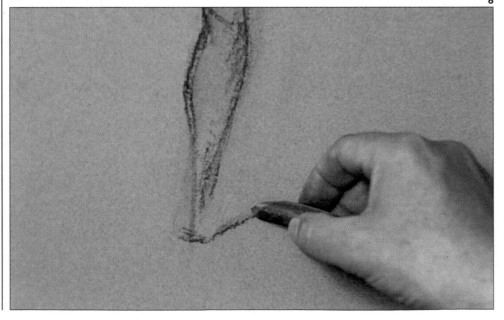

6 Moving down to the standing leg start to indicate the foot by using the side of the charcoal. Leave it as an open tone as opposed to a hard line, making full use of the background colour of the paper.

7 Now add in the side of the breast which is just showing and return to the foot, defining it and the toes of the bent leg with the tip of the charcoal. To soften the tone of the sole of the foot and the leg, use the technique of gently smudging the charcoal and redefining with the tip.

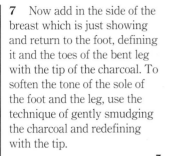

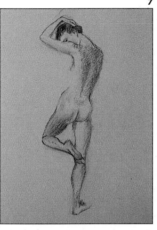

8

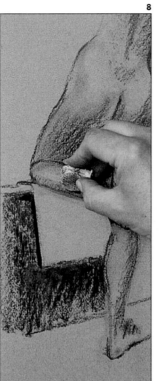

8 Now to add a suggestion of the background details. First add a section of the bath by drawing in the shape of the towel then a little of the edge to the left. Next, fill in a small amount of the side of the bath by using the side of the charcoal, and the tip with a scribbling action, then fix again. The modelling of the figure looks slightly solid which can be remedied by taking an eraser and literally 'drawing' it over these areas to gently lift the charcoal.

9 Even though lifting the tonal areas has helped a great deal in creating a more three-dimensional feel, the figure as a whole still looks rather flat and lifeless. With a white opaque pastel, or white chalk, establish the contrasts in the figure by adding highlights across the body. Before you do anything else fix the work again. This is especially important if you want to avoid any accidents such as smudging the whole piece with your sleeve.

9

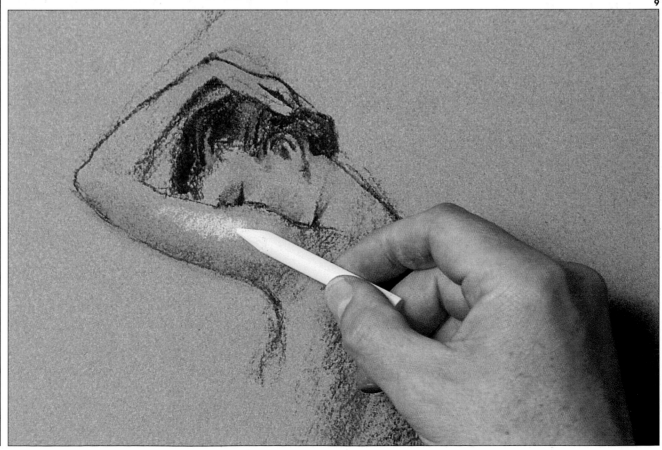

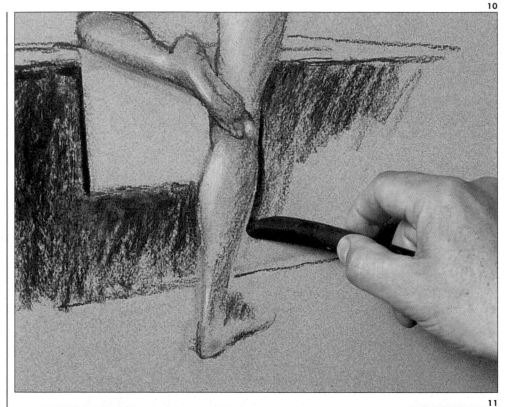

10

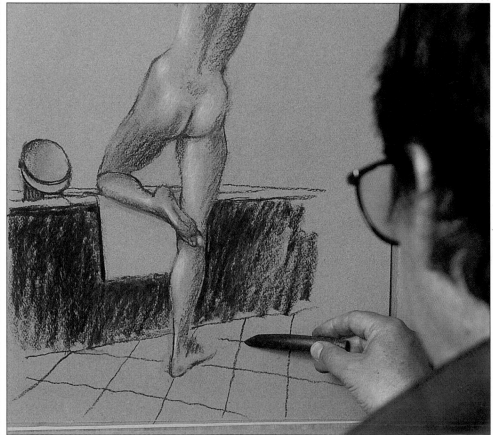

11

10 At this point it is a good idea to step back and take an overall view of your drawing. At the moment it is looking unbalanced as the background has only been suggested to one side. With the pointed end of the charcoal draw in the edge of the bath, including the end, and with a light scribbling action, fill in part of the side, to the right.

11 Although you could decide to finish at this point, on reflection, and by referring back to the original reference, it would seem that more details of the bathroom would add to the drawing. With the pointed end of the charcoal sketch in the mirror and draw the tiles in freehand.

12 Add the basket on the right end of the bath, again using the point of the charcoal, and employing short uneven dashes vertically, then shading up and down over the top, to add the shadows. Finally add some shading to the towel and fix the whole work one more time. Step back, and we think you will probably agree that enough is enough and this is where to stop. Although there are other details such as the basket on the floor, the taps and the shelf, you will often need to edit out such detail or you could end up with a cluttered drawing with the main subject – the female figure – lost in the middle.

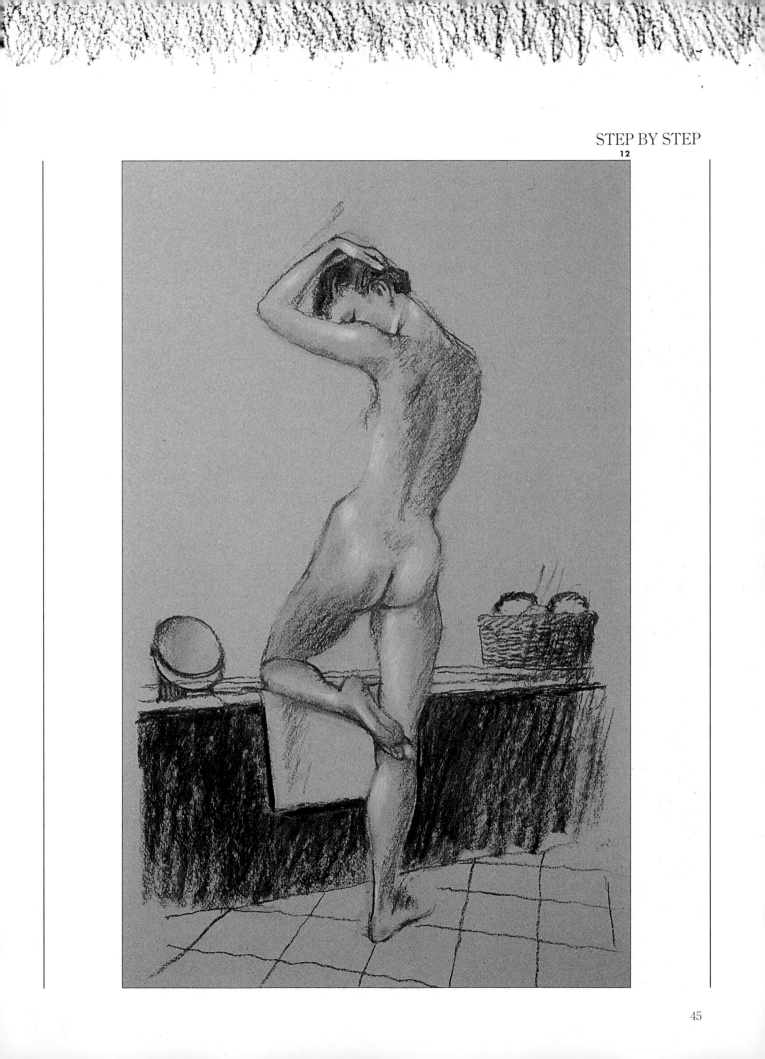

Chapter 4
Dry Colour

Dry colour refers to any medium which can be used to produce a drawing or sketch in colour. There are many media worth experimenting with such as coloured pencils, wax crayons and studio sticks. However, in this chapter we concentrate on conté pencils and pastels.

Conté has been around for years in the form of crayons, or sticks. However in more recent years the sticks have been encased in wood, which makes them appear more like coloured pencils. The similarity stops there because conté is much softer and chalkier. Therefore you have the smoothness of a soft medium, constricted in a case, which in turn will enable your approach to be much tighter.

Pastels, on the other hand are exceptionally versatile and are difficult to match for their ability to produce quick, on-the-spot sketches where a bold approach is required. They come in a vast range of sumptuous colours and can be used both as a painting and a drawing medium. More recently oil pastels and pastel pencils have been developed to further increase the scope of this medium. Pastels really came into popularity about two hundred years ago with the French Impressionists, particularly Edgar Degas, and have remained a firm favourite with artists ever since. This is hardly surprising given their amazing versatility and the fact that they are quick and easy to use.

Materials

CONTÉ PENCILS AND PASTELS

Conté Pencils

Traditionally, conté was only available in the form of oblong sticks and in a restricted colour range of black, white, grey, sanguine, sepia and bistre (earth colours). Nowadays they are produced in a wide range of colours and – like pastels – are also available in pencil form.

Conté pencils are made from pigment and clay bound with gum which is pressed into rods and encased in wood. They are softer and less waxy than ordinary coloured pencils, but not as soft and crumbly as pastels. Because they can be sharpened to a point they are ideal for detailed linear work – and are less messy to use than conté crayons. As with coloured pencils they can be bought individually by the stick or in boxed sets of assorted colours. This is useful as it enables you to start out with a basic set and then add to it as the need arises.

Pastels

Pastels are made from pure pigments and chalk bound with gum and moulded into square or round sticks. They come in three grades – soft, medium and hard – the soft grade containing more pigment and less gum. Soft and hard pastels each produce a different range of textures and effects, and the two types can be combined quite happily, and to good effect, in the same painting.

The nature of pastels does not allow you to physically mix the colours, so they are available in every hue and shade under the sun. This can make it difficult when you come to choose which colours you need, but you can buy boxed sets of assorted colours. Some of these even comprise selected colour ranges covering specific subjects such as landscapes, portraits and still life, which should help you immensely. Be warned though, they are exceptionally messy to work with.

Oil pastels have an added binder of oil so they are not as crumbly as pure pastels and do not smudge excessively. Instead of a soft velvety texture, oil pastels make thick, buttery strokes. They respond rather like oil paints so you can work into them with a brush dipped in turpentine for a wash effect.

Supports

When working with pastels or conté pencils remember that the colour of the paper will play an important part in your finished picture. This is because dry colour sticks are worked loosely and sketchily rather than in solid blocks of colour, therefore the colour of your support will inevitably show through in some areas. So try to choose a tinted paper which either harmonizes with your subject or provides a contrast.

Because of their slightly powdery texture, pastels require a paper with enough texture, or 'tooth' to hold the pigment particles in place. Ingres paper is perhaps the most suitable as it is available in a wide range of colours and has a rough surface. In fact any paper that has a textured finish – even fine sandpaper – can be used. Conté pencils, being less powdery, can be used on a smoother grade of paper.

Other Equipment

When working in pastels you will need to spray your work with fixative to bind the pastel particles to the paper and protect it from smudging. Another handy tool is a large, soft brush to brush away any excess dust which is invariably left when working in such powdery medium. A torchon (a stump of rolled paper) is useful for blending pastel colours, though a rag, cotton bud (Q-tip) or your fingertip would do the job just as well. Finally, you will need a scalpel or craft knife to sharpen the points of conté pencils and pastel sticks.

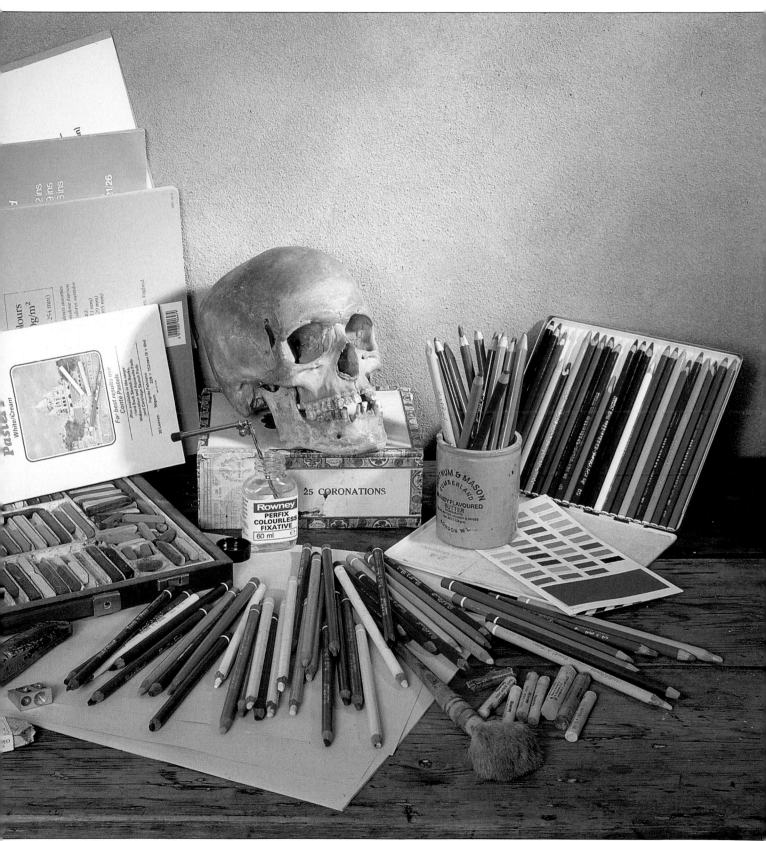

Techniques

CONTÉ PENCIL

The beauty of conté pencils lies in the infinite range of colours you can achieve through optical mixing. When working in conté pencils colours cannot be physically mixed together on the palette as they can with paints, but a whole range of colours can be achieved through optical mixing – laying one colour over another. From the appropriate viewing distance these colours appear to blend together, but the effect is more vibrant than an area of flat colour because the strokes are broken up.

Crosshatching

As we explained in the graphite pencil techniques section (page 31), crosshatching is where two or more sets of parallel lines are combined, one set crossing the other at an angle. With conté pencils this can be taken a stage further and used as a way of optically mixing colours in a very clean and crisp way. It is important when using this technique that your pencil is always sharp *(1)* and this is best done with a craft knife or sharp blade.

Carefully crosshatch over the entire area with one colour and then crosshatch over it in another colour *(2)*. Apart from creating an interesting textural effect *(3)* the overlaid strokes produce colour mixes where they intersect with each other.

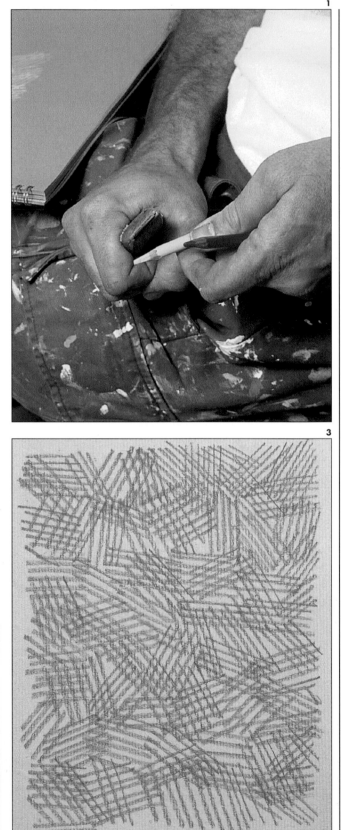

1

2

3

50

Pointillism

Pointillism is a way of building up an area with small dots of pure colour and comes from the French word *point* meaning dot. The dots are closely spaced, but not joined, allowing some of the toned paper to show through. Start in one colour and fill the area with dots. Change to another colour and add more dots to the spaces left by the first colour. From a distance these dots appear to merge into one mass of vibrant colour. However, it is important to note that this vibrancy is only achieved when the colours are of the same tone.

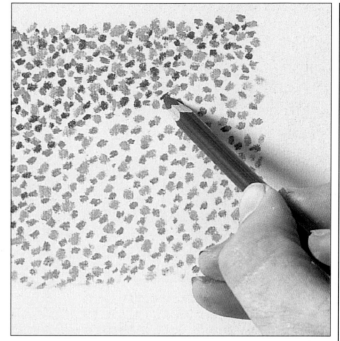

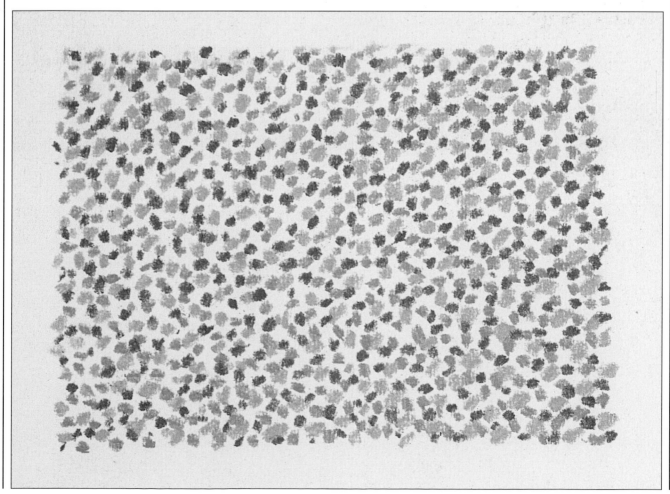

PASTEL

Linear Strokes

When taking up pastels for the first time it is important to practise the various strokes that are achieved by using the stick in different ways. Although the pastel used in these examples is a special hand-made type which is much fatter than the normal, commercially produced varieties, the basic strokes are identical. Using the pastel on its side *(1)* produces a broad band of colour which is perfect for filling in large areas. By running the edge of the stick down the paper *(2)* you get a thin line of dense colour. A flat end of the pastel *(3)* produces a band of colour as thick as the pastel. Finally, by sharpening the pastel to a point *(4)* you will get a very thin, sharply defined line.

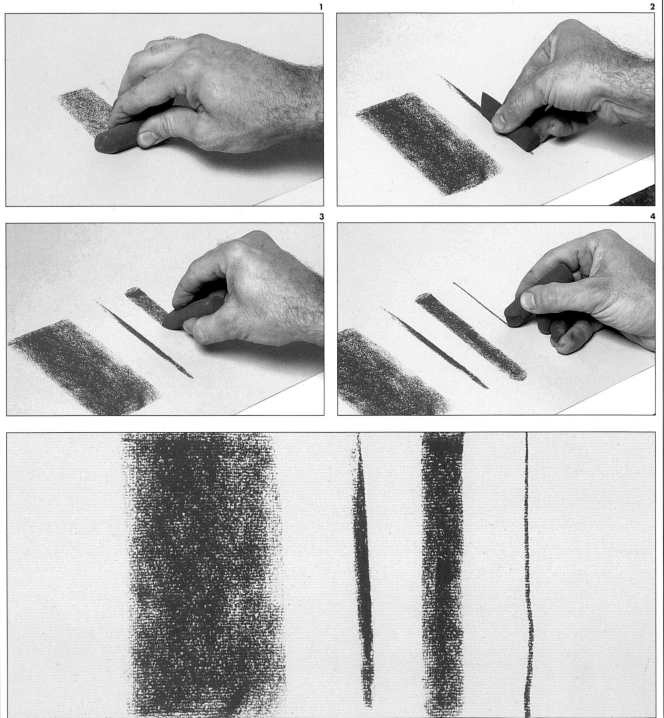

Scumbling

Scumbling is a term used to describe the technique of mixing colours optically by laying one colour over another. Start by laying a loose tone of colour from the left-hand side, then change to another colour. With this second colour begin from the right and continue until it crosses over the first colour. Where the colours overlap they mix giving the illusion of a third colour.

Blending

As you can see from the previous technique when one pastel colour is drawn over another they will naturally blend on the paper to form a mixed colour. In reality this is optical mixing, but it is on such a fine scale – as the particles of pastel colour mix together – that it appears to be an actual mixing of colours. Loosely scribble in an area and then change to another colour. As you cross over you will find that it picks up and blends with the colour underneath. These can be further blended by gently rubbing over the area with your finger, a torchon, a brush or a piece of tissue. This merges the two colours to produce a subtle and smooth transition of colour.

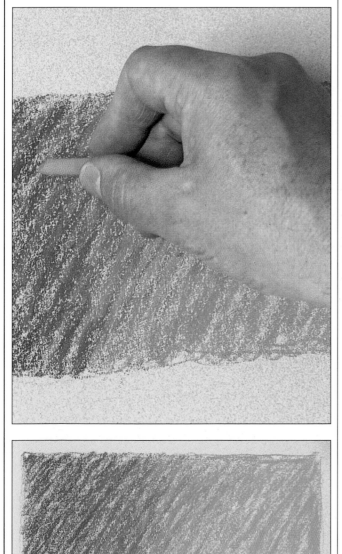

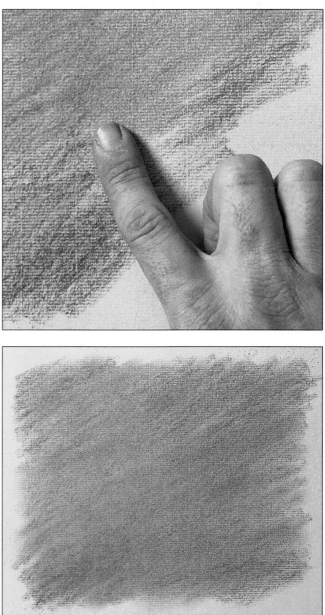

Male Torso

CONTÉ PENCIL

Not all of us have someone to hand who is prepared to pose naked for them. Even professional artists can sometimes find themselves without a suitable model. This is where photographic reference can prove its worth. It is always preferable to be able to pose and light your own subject, but the challenge of working with someone else's composition can open up new dimensions. In addition, the range and scope of varying models and poses is infinite.

For this project we bought some fitness and body-building magazines and immediately found the reference we were after. We wanted to be able to concentrate on depicting muscles since they can make a torso so contoured and interesting. But, at the same time, we did not want anyone too muscular since there is then a real danger of producing a drawing which looks like a caricature. Overly muscular men can look very strange when taken out of context!

When working with any coloured drawing medium the first thing you must consider is your paper – its type and colour. Your choice, of course, will depend on what you are trying to achieve. For a loose, sketchy picture you would need a rough paper to break up the stroke. But, in this case, you will be performing fairly delicate hatching, and you will not want a paper which is too rough. Whatever the texture, it will need to be of a quality that will withstand pencil strokes. The colour of the paper is obviously vitally important as it will show through in the finished work. You could select a normal white paper and allow your piece to stand up on its own. Otherwise pick a tint which complements and can help you with your drawing. In this case, find a sheet which relates to the mid-tones of the flesh as this is the dominant colour in the study and it will be easier to develop the tonal extremes of shadows and highlights from this medium tone.

1 Gather together a limited number of conté pencils which match the main colours present in the reference – yellow, red, orange, pink, dark brown, dark blue, white and a reddish purple. You will use a few extra colours in the background to add definition, but we will cover these as and when required. By limiting your range of colours in this way you will maintain a sense of harmony that could easily be lost if too many varying colours were juxtaposed.

Start by creating an outline drawing using colours which match the reference – dark brown for the hair, orange for most of the body, blue for mid-shadows and purple for areas in deep shadow.

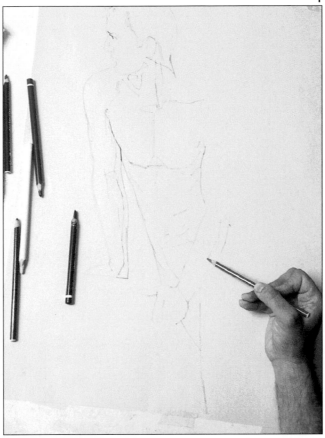

2 To make your progress as effortless as possible, mark in the main light and dark areas right away. Lay a loose, yellow hatch down the left arm, switch to red to hatch in all the areas of warm shadow and then to orange for the right leg. Loosely mark in the hair and the deep shadows under the right arm and on the neck with your dark brown. Spray these initial marks with fixative to prevent any smudging.

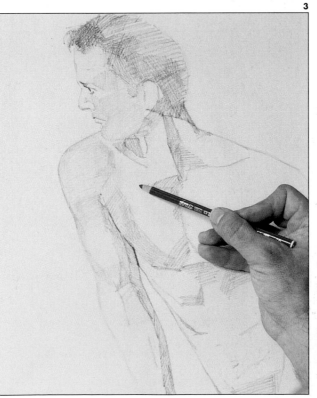

3 Now the process of building up the figure begins in earnest. Re-hatch over some of the hair with dark brown to create a crosshatch which, by its nature, appears to be of a darker tone. You can then use this same trick to model the muscles on his left arm by hatching more yellow over the darker areas.

Also use the yellow to hatch in the highlighted cheekbone of the man's face. Then switch to your red conté pencil to further describe the face and the shadowy areas around the muscles on his torso.

4 Again spray your drawing with fixative because you are now going to hatch one colour over another to create an optical blend (as described on page 50). With your orange conté, lay a careful hatch over both the shoulders and all the sections on the man's torso which are in shadow. Over some of these areas you will already have laid a red hatch so take care to lay the orange hatching in a different direction to make a two colour crosshatch. This creates a subtle optical blend because red and orange are such similar colours.

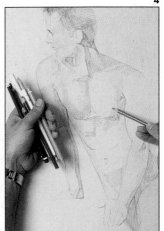

5 To further exploit the optical blending hatch over all the mid-tone areas with yellow and the deepest shadows with dark brown. Allow the areas of hatched colour to overlap so that further combinations of colour occur spontaneously. Darken the harsh shadow under the right leg by putting a dense scribble of dark blue and black over it. Switch to pink and lay a very loose scribble of colour down the right leg, and then crosshatch orange over it to indicate the darker areas.

6 The figure is almost complete so now you can add a suggestion of background colour. Since the tone of the paper shows through the crosshatching in the torso and is an integral part of the colour scheme, the background colour needs to be significantly different to help project the figure. The harsh white background in the original reference shot works well, so play safe and use white conté chalk to hatch roughly around the figure. Try to lay almost solid white around the outline of the torso since this 'cutting-in' helps to bring out the form. You can also use the white chalk to add some pure highlights on his collar bone and face.

7 To counter the white and help balance the tones across the drawing, you now need to add a dark shadow behind the man's torso. Mark in a rough outline for the shadow with a blue/purple conté pencil. Then loosely scribble and crosshatch over the area with the blue/purple pencil, a red/purple pencil and finally with a dark grey.

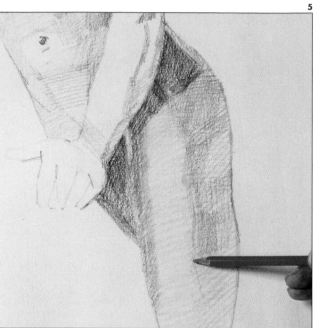

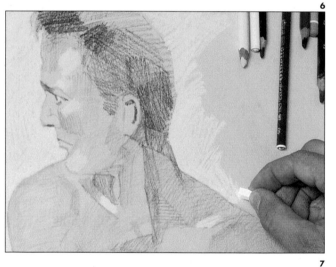

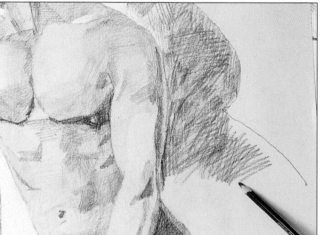

8 Finally, to finish your drawing, gently hatch over the soft highlight areas on the muscles – notably the pectorals and the shoulders – with a white conté pencil. This gives a very subtle effect which is totally different to the conté chalk you used in step 6.

As with any project executed in dry colour your final step must be to spray the work with fixative to prevent any possible smudging in the future. But before you do spray your drawing step back and take a final view of it. If you feel anything needs going over do it now, but do not spoil the sketchy feel of the image by being tempted to overwork any specific areas. The knack with this sort of piece is to know when to stop. Although quite a lot of attention has been paid to the muscles on the man's torso, his hands have only been suggested. Likewise, the background tone gently fades away towards the bottom. A suggestion of spontaneity is achieved by leaving the drawing seemingly unfinished.

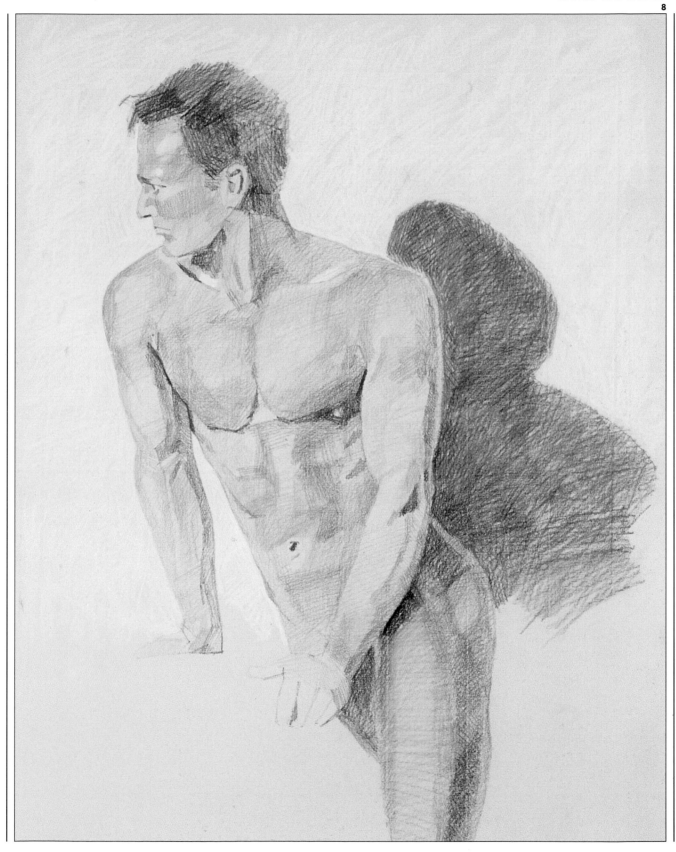

Laura on a Bed

PASTELS

At this stage of our photo-shoot we were rather concerned because one of our models had not turned up. Luckily for us our photographer's assistant – as you can see from the photograph – is particularly pretty and volunteered to help us out, so for once she was on the other side of the camera!

Working with pastel is very similar to working with charcoal, except with the added dimension of colour. By this we mean that the style is free and bold, allowing you to use your imagination and to interpret the colours as you see them. In this project, we start out by keeping it very loose, gradually building up the image and tightening things up as we go. Pastels need to be kept fresh looking so try not to overwork them. Too many colours used densely will create muddy hues. You will find the best effects are created by mixing colours optically on the surface with broken colour techniques.

Pastel paper comes in a wide range of pale tints. You will need to choose a tint to complement your subject as parts of it will show through the work. This will not only enhance the overall effect but create a feeling of harmony, pulling all the elements together. Pastel is a spontaneous medium which allows you to experiment, so relax and have some fun.

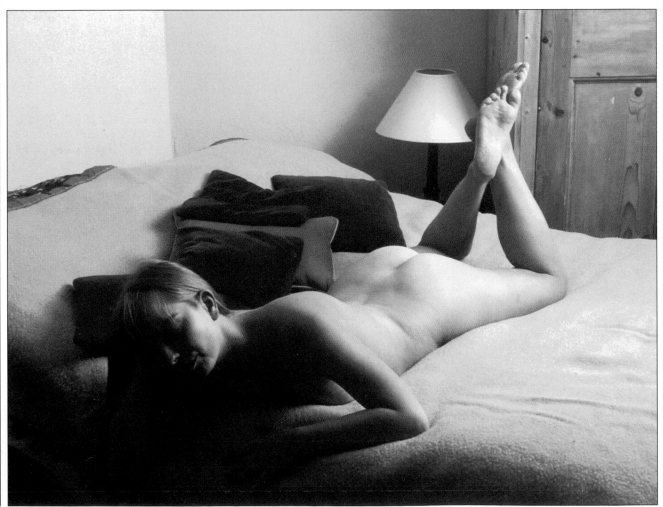

1 Start by drawing a frame on to grey Ingres paper. This will create a confined area to work within, which will prevent you from 'wandering' all over the paper. The reason for using a pale green stick is that it is the colour of the bedspread and will therefore introduce it into the composition at an early stage. With the side of the stick roughly map out the figure. Switch to a pale pink stick to complement the green and continue to sketch in the figure. Changing now to an orange stick, start giving more definition to the legs and the shape of the body.

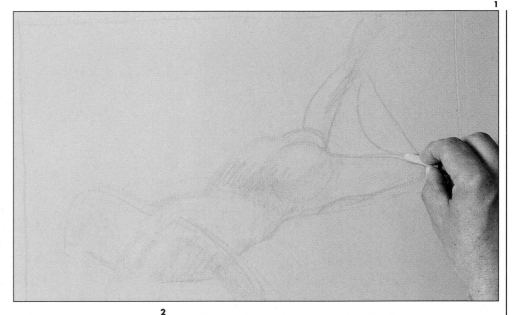

2 Now use these colours to build up the frame, adding to the overall harmony. With a dark yellow colour re-define the right-hand side of the body and the legs using the tip of the stick. Switch to a deep reddish-brown and draw in the contours of the back and the shapes of the cushions. Notice how the legs have 'slimmed' down since the initial lines were laid. Do not worry about the other lines showing as these will be hidden later on by incorporating them into the background. With the side and the tip of the reddish-brown stick, add some loose shading to the cushions and down the front of the body where it is in shadow. Switch to a pale green and add a little shading to the foreground. Finally, with a white stick start to add a few highlights.

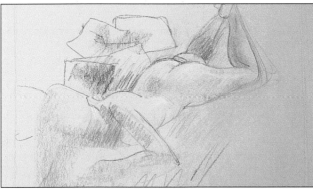

3 As you can see the drawing is taking on a more solid look and really beginning to take shape. We are not going to include the background furniture so use a pale violet and pale yellow stick, which will create an interesting inter-mix and texture for the background and add warmth at the same time. Continue with these colours down to the foreground using the side of the stick. With the reddish-brown stick return once again to the main figure adding more definition to the outline and curves of the body.

4 With the orange stick from step 1, add some tone to the legs and extra colour to the cushions. Once again use the tip of the stick but hold it lightly halfway down – as shown here – to achieve a loose scribbled effect.

5 Switch to the reddish-brown colour and continue to fill in the cushions with the same scribbling action, and for a more solid effect use the side of the stick. Take a little of this colour into the background to keep a feeling of unity in the picture as a whole. Continuing with the background, change to the pale violet and cut in and around the cushions and the figure with the side of the stick. Now introduce a new colour – maroon red – for the first stages of the face and the surrounding shadows.

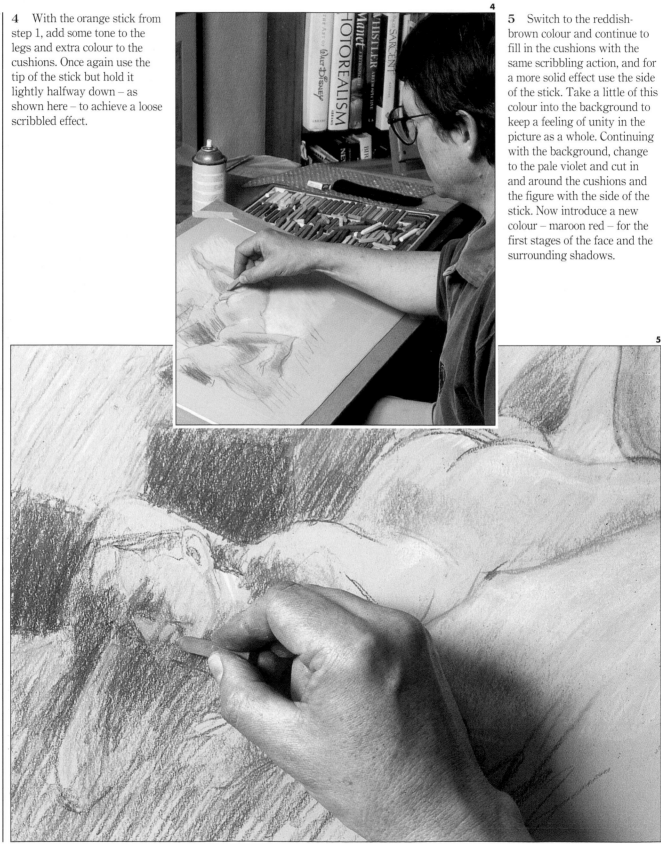

6 Continue to work up the face and to add definition to the hair with the maroon stick. Changing to a brown pastel, lightly scribble over the hair and around the left arm and across the chest and upper-

right arm where the dark shadows fall. Switch to a lilac stick and with loose strokes go over the background keeping tight around the cushions and the legs but not extending out to the top of the frame.

7 Before you continue any further, fix the whole work and leave it to dry. This is because the next stages of the painting involve a lot of tight, detailed work and fixing it will mean that any superimposed colour will not merge with colours beneath, remaining sharp-edged and pure. With a white stick, add the highlights to the

side of the face and chin, below the chest, along the right arm and along the back and cheeks of the bottom. Change to the pale pink stick and lightly scribble over the lower back and then gently rub with your finger to soften the tone.

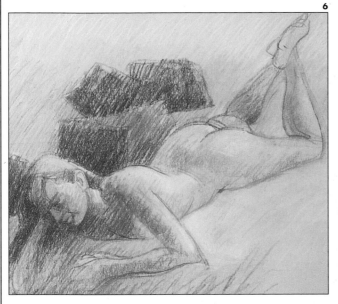

6

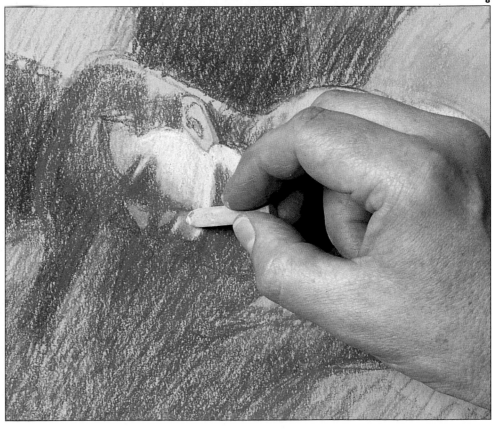

7

8

8 Switching back to the brown stick, loosely scribble across the whole of the area in the front which is in the shadows. With the same stick add more definition to the darkest areas of the face and to the hair. With the pale pink stick strengthen the mid-tones of the face using a small circular motion.

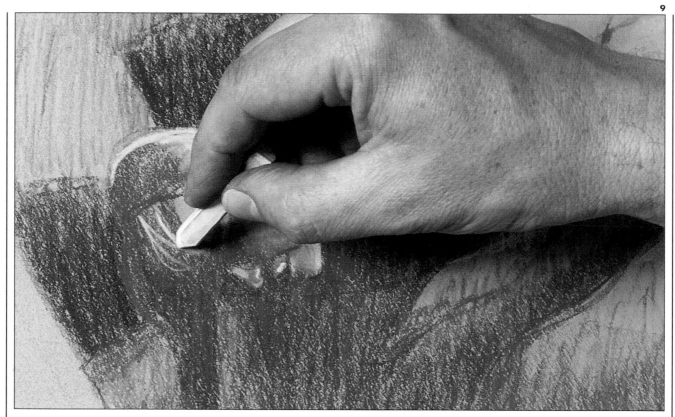

9 With the white stick add the highlights to the nose and upper lip. Changing to the pale yellow, follow the contour of the hair running down the back of the head and add the highlights along the side of the hair and to the fringe.

10 Moving on to the background and with the same yellow and white sticks, scumble (see page 53) over the upper part of the background. Switch to pale brown and fill in the centre cushion before redefining the legs and the feet. Work these up further by alternating the colours between the pale brown, pink and orange which give you the flesh tones and do not forget the dimples on the lower back.

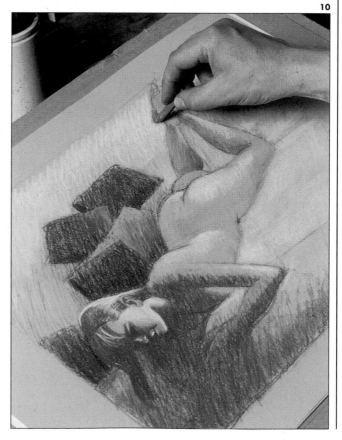

11

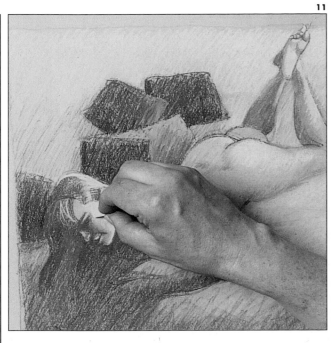

11 Now with the white stick add in the final highlights. Refer back to the original reference and start with the soles of the feet and work down the body, finishing with the cheek of her face.

12 Step back to take an overall view of your work before you fix it. Because this has been an exercise in gradually building up detail, it is often difficult to know when to stop. It is far better to stop too early and come back to it, rather than end up overworking the piece. If you find you have become too involved and cannot be objective, try looking at your work in a mirror. One of the main questions you should ask yourself is have you captured the essence of the subject. If the answer is yes, you have achieved something regardless of anyone else's opinion!

12

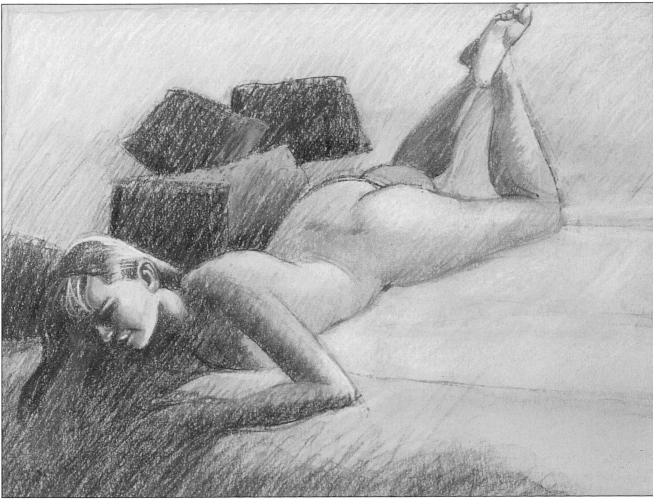

Chapter 5
Watercolour

In this chapter you are finally going to experience the thrill of using real paint. Although you will have gained some knowledge about working in colour from the previous chapter, it must be said that dry colour does not really possess the versatility and range of effects that are possible when working with paints. In addition, 'wet' colours can be physically mixed together on the palette to create an infinite range of hues, whereas dry colours can only be mixed optically, on the paper.

Pure watercolour is perfect for applying thin, translucent washes of colour on white paper. Gouache, an opaque form of watercolour, is better suited to laying flat, opaque patches of colour. The translucency of pure watercolour is lost, but

gouache has the distinct advantage of allowing the artist to work from dark to light, building up from the shadows to the highlights. A particularly enjoyable approach is to combine both pure watercolour and gouache in a painting and exploit the best features of both.

Although watercolour has the reputation of being a difficult medium to master, the basic techniques are really very simple. Most beginners fail because they rush into the business of creating a picture without first getting to know how the medium behaves and what it is capable of. Take your time practising the basic techniques at the beginning of this chapter, before moving on to the step-by-step demonstrations.

Materials

WATERCOLOUR

Paints

The first decision to make when taking up watercolour painting is whether to go for pure watercolour or gouache. Pure watercolour is available in a variety of different forms, from dry cakes, pans and half pans – which are very small blocks of solid colour – to tubes and bottles of concentrated liquid. Basically it is made from pigment bound with gum arabic. The quality of pure watercolour is reflected in the price: the more you pay, the purer the pigment. It is really only with these pure pigments that you can obtain the brilliance and translucency that makes it such a beautiful medium to work with. Tubes and bottles are very good for laying larger areas of wash, and of course pans are ideal for outdoor work, as they will fit into a box where the open lid can act as your palette.

Gouache is similar to pure watercolour, but contains a proportion of chalk which gives it an opaque quality. As with pure watercolour there are numerous colours to choose from, but since it is so simple to mix colours, only a basic selection is required to get you going.

Palettes

Palettes are available in ceramic, enamelled metal and plastic. Those which contain a row of small recesses with a larger row at the front are the ideal answer for mixing pure watercolour from tubes. The paint is squeezed into the small cavity, and then moved into the larger one to be mixed with water as and when required. Although the ready-bought palettes are very useful, it is always possible to improvise with egg-cups and saucers from the kitchen.

Brushes

Without doubt the best watercolour brushes are red sable, made from the tail of the Siberian mink. Although very expensive, if well cared for, they

will last a lot longer than the less costly varieties and there will be no problems with moulting hairs. The other types available are made from squirrel – often called camel hair – ox hair, and various synthetic materials. The Chinese hog hair brushes, which are now widely available, are extremely useful as they hold a lot of paint for laying washes but also come to a fine point for painting details.

You will need a good selection of brushes in small, medium and large sizes: flat brushes for laying washes,

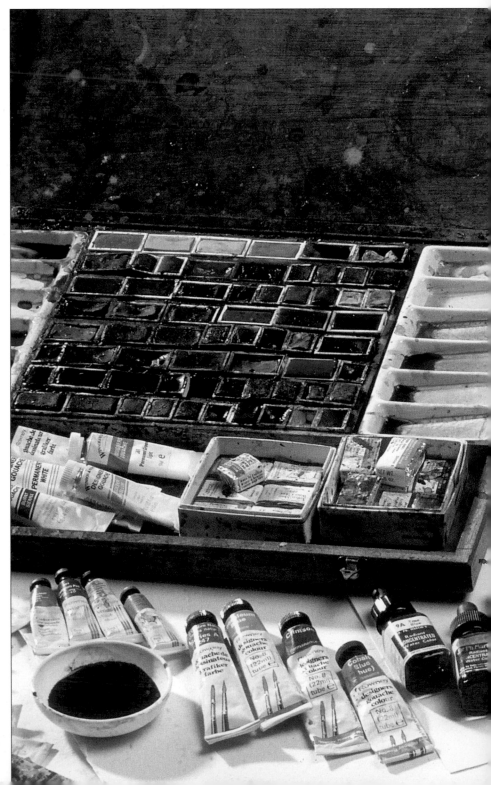

round brushes for making expressive strokes, and small brushes for details.

Supports

Watercolour paper is available in a variety of textures, weights and colours. Textures range from rough to semi-rough (cold-pressed) and smooth (hot-pressed) but the most popular choice is semi-rough. The weight (thickness) of watercolour paper ranges from 90lb (180gsm) to 300lb (600gsm). The lighter papers tend to wrinkle when washes are applied and need to be stretched (see page 68). Papers of 140lb or more do not require stretching. Pure watercolour is normally used on white paper, which adds brilliance to the transparent washes, but gouache works equally well on white or tinted papers.

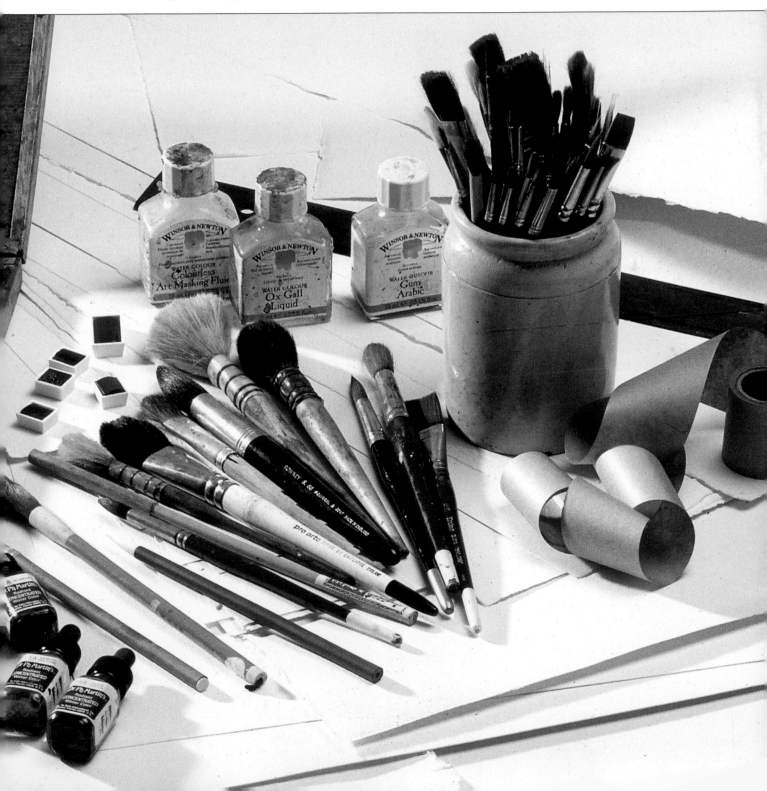

Techniques

WATERCOLOUR

Stretching Paper

Whether you use pure watercolour or gouache, a certain amount of diluted colour will always be used in a painting. Paper absorbs water which causes it to stretch, and consequentially it shrinks as it dries out. Unfortunately, paper rarely dries flat, instead it buckles and wrinkles which ruins your finished painting. The way to overcome this problem is to pre-stretch your paper. You can buy

ready-stretched paper, but you pay a premium. Stretching your own is so quick and easy that the ready-stretched does seem to be an invitation to be extravagant and lazy at the same time.

To start with, collect together the various bits and pieces that you will need *(1)*: a drawing board, a bowl of clean water, a sponge, some gummed paper tape and of course a sheet of watercolour paper. Tear off a strip of gummed paper tape for all four sides of the paper, allowing a few extra inches on each end to be safe.

Lay the paper on the board and fill the sponge with water. Then squeeze the sponge over the middle of the paper *(2)* so that you create a large puddle of water.

Now use the sponge to gently spread the water all over the paper *(3)*. The idea is to get the paper quite damp rather than soaking wet as this could easily damage it. If the paper is fairly thin you should only need to dampen one side of it. However, for the heavier papers you will need to carefully turn them over and then wet the other side in the same way.

Re-dampen the sponge, and run each strip of paper tape along it *(4)* so that it becomes sticky. You can try licking them all, but be warned, you will probably feel

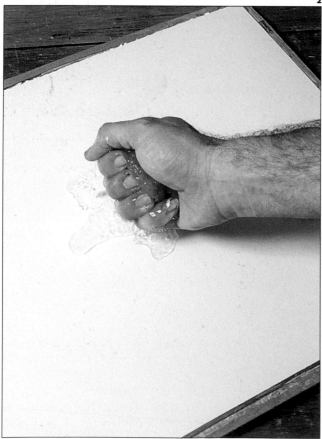

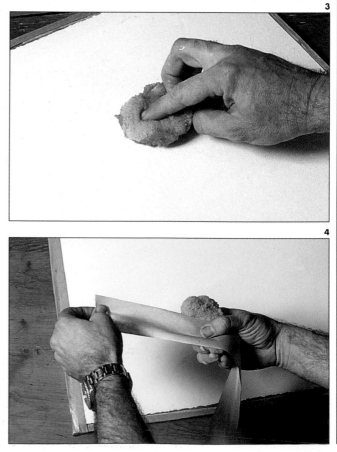

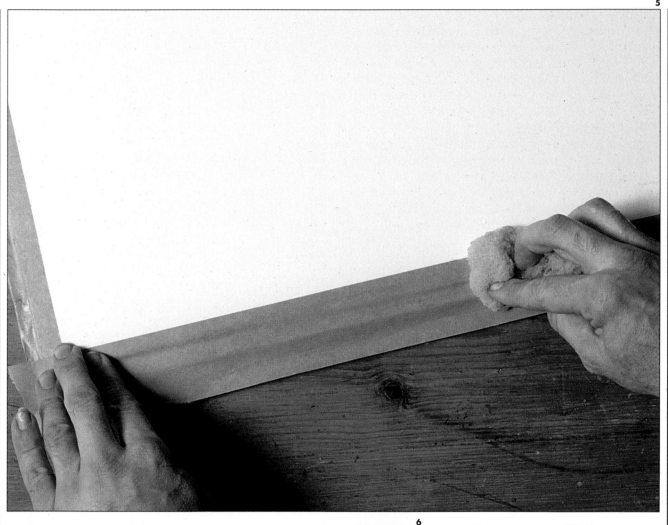

5

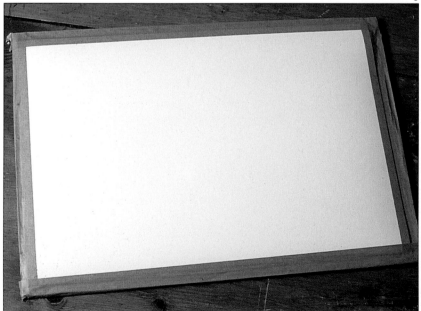

6

very ill afterwards. Whilst you are wetting the gummed paper, your watercolour paper will be absorbing all the water you laid across it and quietly stretching behind your back.

Lay the gummed strips along the side of the paper, overlapping them onto to the board, and then run along each of them with the damp sponge (5), pushing down as you go. Make sure the paper is flat, doing the opposite side first so that you can gently pull out any obvious wrinkles. You do not need to use any force since the drying and contracting of the paper into a set shape will be enough to flatten it.

Allow the paper to dry overnight, and when you return the next day you will have a beautifully flat sheet (6) just waiting to be painted on.

PURE WATERCOLOUR

Laying a Flat Wash

One of the most important techniques when working in watercolour is that of laying a flat wash. The first step is to mix your chosen colour with plenty of water in a dish, making sure that you prepare a sufficient amount to completely cover the area that you are painting. Load a large brush with paint and lay it in long, even strokes horizontally across the paper, tilting the board towards you so that the colour pools at the bottom edge of each band and can be picked up with the next stroke. When you have covered the whole area, pick up any excess paint with a dry brush or small piece of tissue, before leaving it to dry. You must still keep the board in a tilted position to avoid the paint from flowing backwards which will cause the wash to dry unevenly.

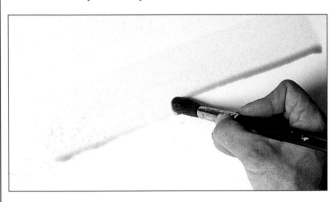

Laying a Graded Wash

The technique of laying a graded wash is to start off with a darker tone at one end which gradually fades into a much paler tone at the other. To achieve this you must mix the colour with some water in a dish and keep a jar of clean water next to it. Load your brush with the paint mix and lay a long band of colour horizontally across the top of the paper, tilting the board towards you. Now dip the brush into the clean water and lay the next band underneath picking up the wet front created by the first band. Continue in this way until the whole area is covered to create a gradation of tone from top to bottom.

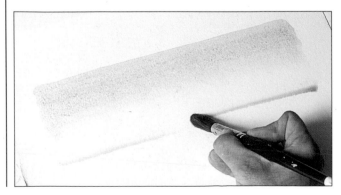

Wet into Wet

Wet into wet describes the technique of laying one colour over another before the underlying wash has dried. This can create some interesting results as the second colour will bleed and merge into the first and enlarge the marks made by the brush.

Wet on Dry

This technique of waiting for the first colour to dry completely before laying another colour over the top will give you a very different effect to wet into wet. Here you can see how the edges of the second colour are clear and well defined.

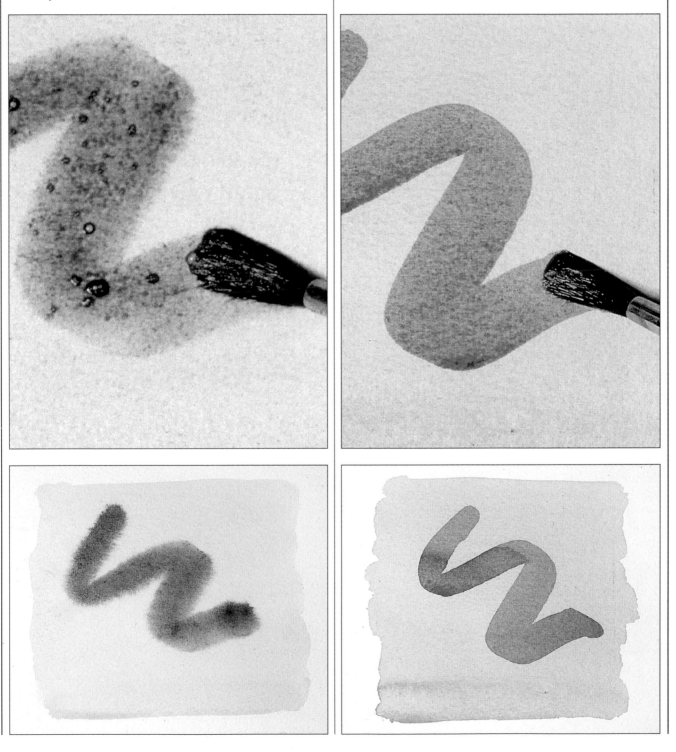

GOUACHE

Wet into Wet

This technique is the same as for pure watercolour – painting one colour on top of another, before the first layer has dried – but because the paint is opaque you can make your second colour lighter. This can create some very exciting results – the marbling effect in this example is one of the most notable.

Wet on Dry

Again this is the same technique of painting over another colour that has been left to dry. This example graphically shows the difference between pure watercolour and gouache, in the fact that you can paint white over a dark colour totally successfully. This enables you to work from dark to light, painting in the highlights at the very end rather than having to leave blank pieces of paper as you would with pure watercolour.

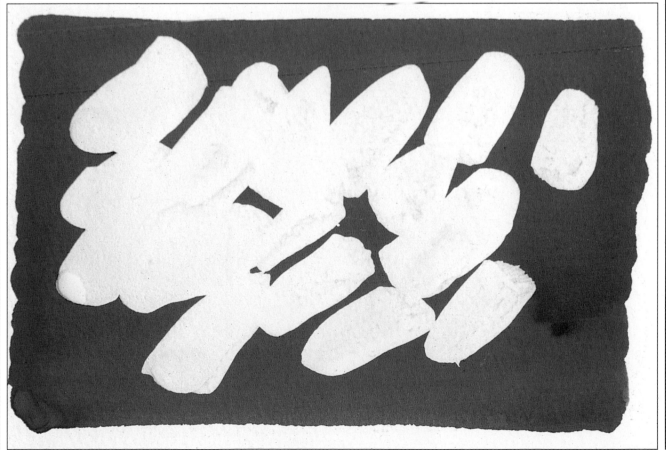

Alice Playing

PURE WATERCOLOUR

For this pure watercolour project, we have as our reference a photograph of a rather cheeky little girl, Alice, playing on her parents' bed. Although it is preferable to work from life when drawing or painting nudes, this scene is the perfect example of when photographic reference can prove its true worth as obviously a little girl cannot be asked to stand still for an hour while someone captures their likeness. And even if you could, the spontaneity would be lost.

A number of different photographs were taken and the artist picked the one he thought would work best as a painting. However, he kept the others close to hand so that he could refer to other viewpoints and exposures if required. The main drawback with using photographs was that there was a general reduction in the variety of skin tones which could have led to a rather flat and lifeless painting. So, in the time honoured tradition of all good artists, he chose to enliven the flesh tones with more subtle variations than were visible in the photograph. Building up the nude from a myriad of different mixes of flesh tones painstakingly painted in various patches on the girl's body can be confusing. You will find it easier if you work from light to dark as the artist did in this project. All the flesh tones in the finished painting (see page 81) are mixed from just a few basic colours. Light washes of tone are laid in first and then the tones built up, by superimposing and juxtaposing washes of paint, building up the three-dimensional form.

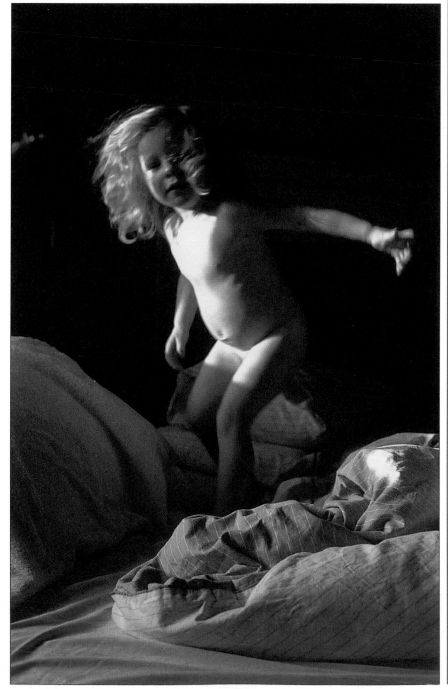

1 Due to the translucency of pure watercolour you must make sure that your initial outline sketch is as pale as possible. So, on to a sheet of pre-stretched watercolour paper (see page 68) gently outline the figure of the little girl with a 2H pencil. As well as marking out the various forms you can also map out the boundaries between major changes of tone to help guide you later on.

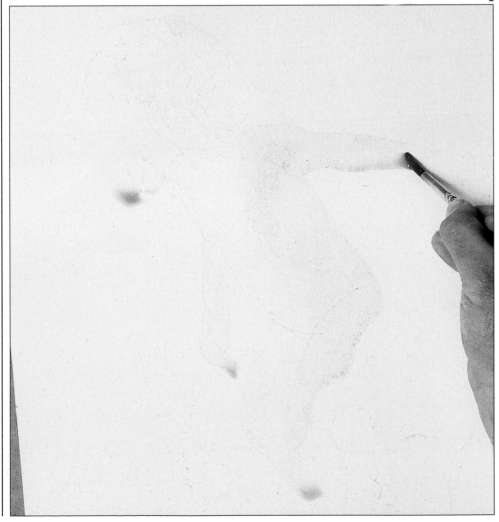

2 For a gentle introduction create a dilute mix of cadmium yellow and brown madder-alizarin. Then, using a no. 8 soft hair brush such as a sable, lay a light wash over the girl's hair and down over the whole of her body. Tilt your painting towards you so that any excess collects at the bottom of the painted areas. You can then easily tack this off either with a clean, dry brush or a piece of tissue.

3 Allow your painting to lie flat until it has dried. Then apply a second wash of your cadmium yellow and brown madder-alizarin mix over the darker sections of the girl. While this dries, dilute some yellow ochre and add to it a touch of cobalt blue. Then use this to loosely mark in the darker sections of her hair.

4 Again allow the painting to dry. Once it has, return to your initial mixture of cadmium yellow and brown madder-alizarin and use it to repaint the darker parts of Alice's body. This time, however, make the mix stronger and darker by adding slightly less water and increasing the ratio of brown to yellow. Once again sit back while the painting has a chance to dry.

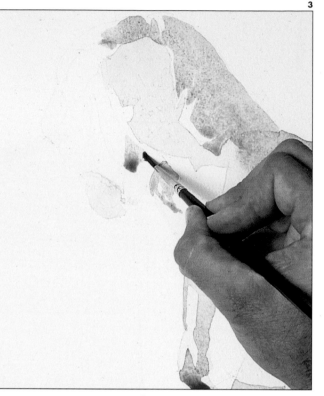

3

5 Let's concentrate on the hair in this step so switch to a no. 4 soft hair brush to give you more control in painting detail. Start by using a mix of yellow ochre (not cadmium yellow as this is too harsh) and brown madder-alizarin to darken the hair to the left of the little girl's face. Work around towards the right-hand side and add in Paynes grey and burnt umber for the deepest shadows in her hair.

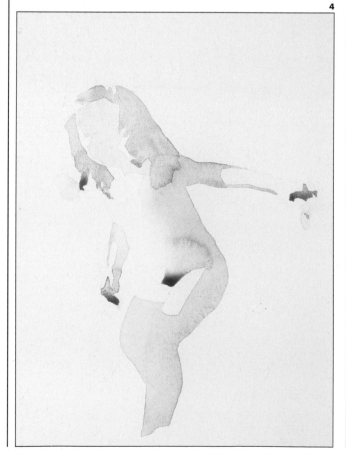

4

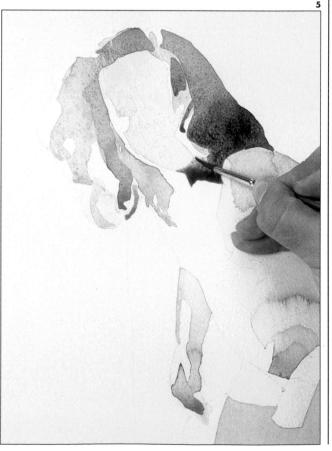

5

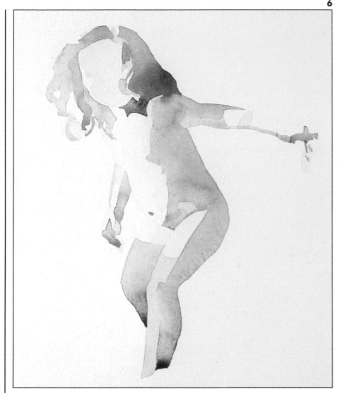

6 Yet again you must let your masterpiece dry totally before you continue. You can speed things up with a hairdryer if you wish, but take care not to use it on too high a heat which will damage the paint surface or too strong or too close which will inevitably 'push' your wet paint all over the place. Mix brown madder-alazarin with a touch of cobalt blue to go over all the shadow areas on Alice once again. As you can see, this slow process of building up tone in layers is paying off since the figure is starting to take on a three-dimensional form.

7 Mix together brown madder-alizarin, cadmium orange and a touch of cobalt blue to create a reasonably deep skin tone which you can use on the girl's face. Vary the amount of water in the mix as you proceed so that you get distinct light and dark areas. For the small section of shadow under her chin increase the amount of cadmium orange in the mix to describe the effect of her skin picking up the warmth of the early morning sunshine.

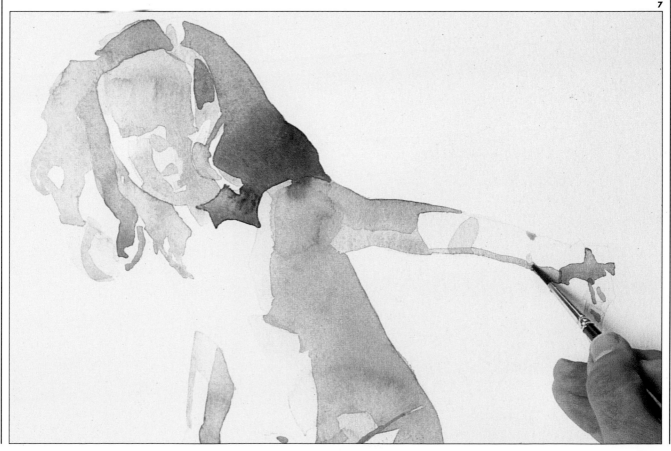

8

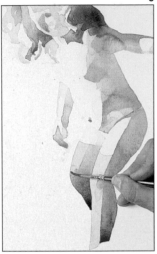

8 Use a loose mixture of yellow ochre and chrome orange, to add further modelling to Alice's face – including the suggestion of her eye sockets and lips – and to repaint a few sections of her hair. By repainting small parts at a time you will create a large variety of tone with very little effort.

Next mix together Paynes grey and chrome orange – keeping it quite dilute as always – to make a dark purple. Then re-paint the deepest shadows down her right-hand side and on her legs.

9 Since the form of the little girl is now so well established, you can digress for the moment and put in some background tone. Make sure that the painting is absolutely dry, then lay a wash of Paynes grey and ivory black over all the background with a large no. 12 soft hair brush. The size of this brush will allow you to cover an area quickly – essential with watercolour – but at the same time will give you enough control to cut in around the figure.

10 Once the background wash has dried, lay a second wash of burnt sienna and ivory black over three quarters of it. This splitting of the background into two 'slabs' of tone not only adds impact but also pulls the viewer's eye down from the top of the picture to Alice's face.

Continuing with the process of modelling the figure, use a mix of brown madder-alizarin and cobalt blue to further deepen the shadows on the face. Then re-paint the darkest sections of hair with burnt umber mixed with Paynes grey. For both these stages switch back to your no. 4 soft hair brush to give you the maximum amount of control.

9

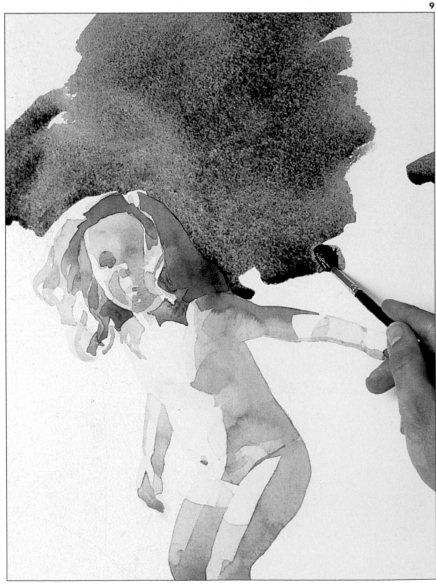

10

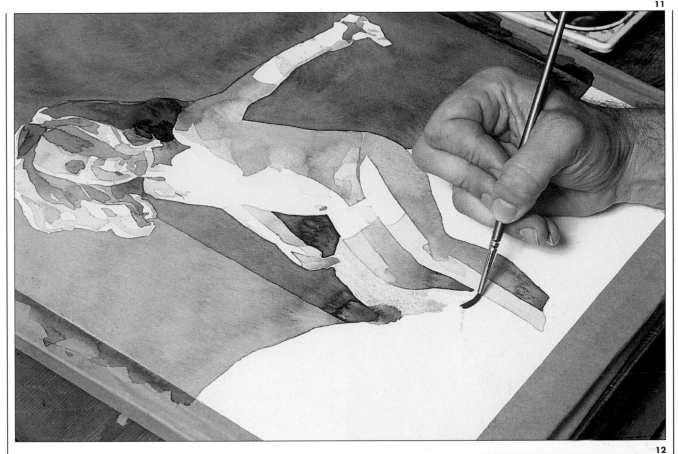

11 Now you can turn to the
only part of your painting not
to have received any attention
so far – the sheets and pillows
of the bed. Switch back to your
no. 8 soft hair brush, as this is
a reasonably large area which
you can treat with broad
strokes. Use a dilute Paynes
grey to paint all the mid-tone
and shadow areas. Allow your
painting to dry before
continuing.

12 Re mix your deep skin tone
of brown madder-alizarin,
Paynes grey and chrome
orange and strengthen those
shadows that need it on the
little girl. Let the paint dry and
repeat the process. With this
process of building up tone
with multiple layers you will
create a wide variation of
subtle tones. It is a slow but
worthwhile process since you
end up with great 'depth' in
your skin tones, something,
that any artist would have
difficulty achieving with only a
few layers of paint.

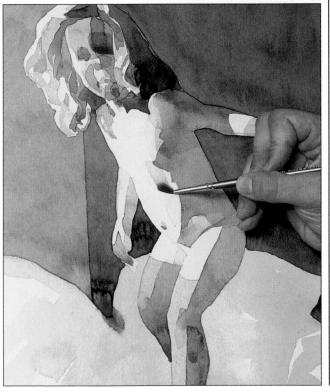

13

14

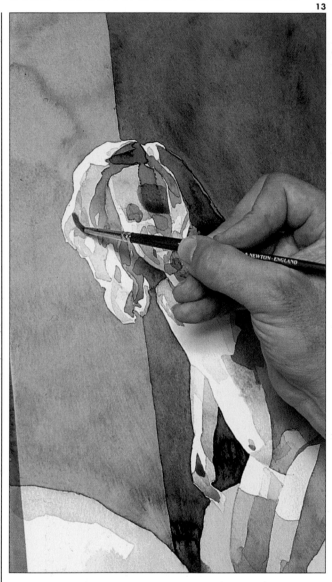

13 To complete the little girl – though not your painting – you now need to turn your attention to her hair. It requires something further to bring it to life, against the harsh grey of the background and the vivid pinks of the body. It needs more impact to enable it to hold it's own. What you need to do is to exaggerate the tonal extremes. This is simple to achieve by using a dilute cadmium yellow to paint over the mid-tone and shadow areas. And then, once dry, re-paint the shadows again for good measure.

14 Finally, to finish your masterpiece, revert back to your no. 8 soft hair brush and a dilute Paynes grey to paint the shadow areas on the cushions and sheets. Allow the picture to dry and then re-paint these shadow areas if you feel they need further strengthening. They should be distinct from the mid-tones you painted earlier, but must not be too dark since you are trying to represent white bed linen in quite a soft light.

15 And so there you have it, possibly your first finished watercolour painting and hopefully not your last! Do not be too disheartened if your finished piece is not up to the standard of the one shown here, the artist in this case has been painting in pure watercolour for quite a few years. That in essence, is the secret of watercolour painting. Plenty of practice is the only answer as you need to learn to predict how the paint will behave. But do not be put off when things do not go as you intended. The real sign of a confident watercolorist is the ability to turn a little 'accident' into a 'feature' of the painting. So the motto with pure watercolour has to be 'keep your brushes busy'.

Rupert

GOUACHE

As we have already explained, gouache is an opaque form of watercolour. This gives it two main advantages over its more well-known relation: the ability to paint light over dark and the potential for a great depth of tone due to the chalk content. We will only make limited use of the light-over-dark ability in this project, and instead concentrate on creating texture and tone with superimposed layers of paint. To that effect, we picked a dark setting of a red leather chair with tartan cushions and a very pale skinned model to contrast with it.

Apart from the stark contrast of tone, this scene also provides three distinct textures: the shiny leather, the woven cushions and the smooth skin.

As with any nude study, the composition is an important element. Here the artist has created quite a constrained effect by having the model pull his legs up towards himself. This then focuses the scene and enables the background to be darkened down even further in the painting to heighten the contrast of light and dark. In addition, this is an easy pose for the model to hold for a long time. You must take account of this when working from life, especially if the model is your loved one or next-door neighbour, and not a professional who is used to holding difficult poses for hours at a time.

1 As with the previous project stretch your paper the day before (see page 68). However, unlike pure watercolour, as gouache is an opaque medium you need not worry about your under-drawing showing because there is little chance of it being visible in the finished work.

Mark out the shape of the body with a graphite pencil – paying particular attention to the proportions of the figure (see chapter 2). Try to work with your picture as upright as possible to prevent any foreshortening.

2 Before you begin to paint collect together all the colours required: burnt umber, yellow ochre, cadmium orange, cadmium red pale, alizarin crimson, permanent white and jet black. Start the painting proper by using a no. 6 soft hair brush to wash burnt umber over the background, dropping in small amounts of all the other colours (excluding the black and white) from time-to-time so that all the colours are present. This will help give the painting a sense of harmony purely through the use of colour.

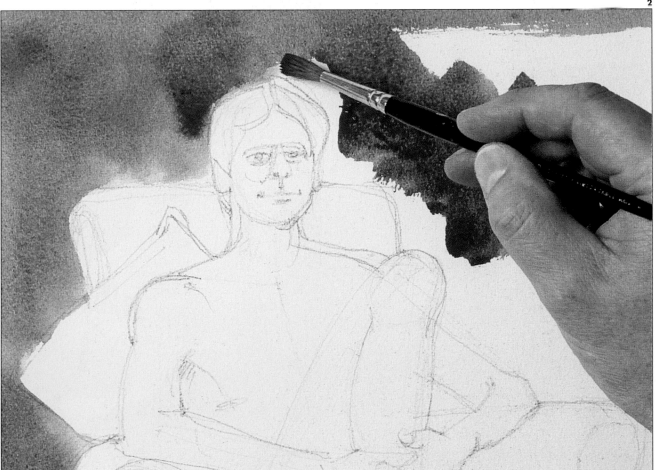

3

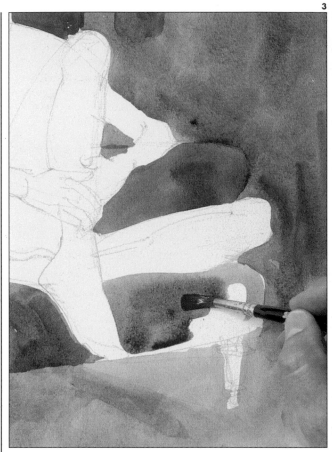

4

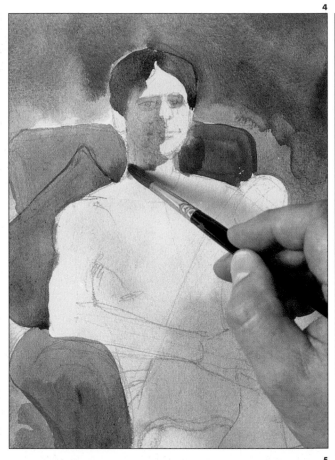

5

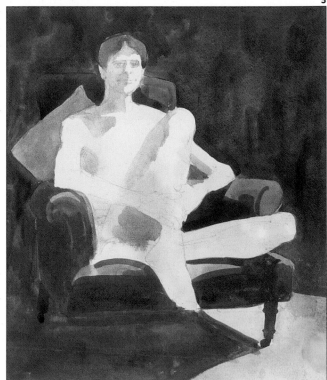

3 Continue establishing the base tones by using a fairly dilute wash of alizarin crimson, with a small amount of cadmium red pale, to block in the form of the chair.

Although these initial washes will be painted over later, small sections will be allowed to show through to add depth and, in addition, they help set the 'mood' of the painting very early on.

4 Use an alizarin crimson wash to mark in the shape of the cushion. Add yellow ochre and lots more water to the alizarin wash to create a pale skin tone. Then, still using your no.6 soft hair brush, paint the last of the exposed paper – the body – with very loose strokes. By painting quickly and loosely you will sometimes find that dark and light areas

form naturally which you can then use. However, do not be disheartened if this is not the case. Give the skin wash a chance to dry by switching to burnt umber and painting a rough representation of the hair. You can then make the burnt umber more watery so that you can paint the shadows on the face and down the body. Once you have finished this allow the painting to dry for at least 15 minutes.

5 When your picture is totally dry, create a wash of burnt umber and add a small amount of jet black, and use it to darken down the back-ground and the section of floor in shadow. Then use a mixture of alizarin crimson, jet black and a touch of cadmium red pale to describe the shadows on the red leather chair.

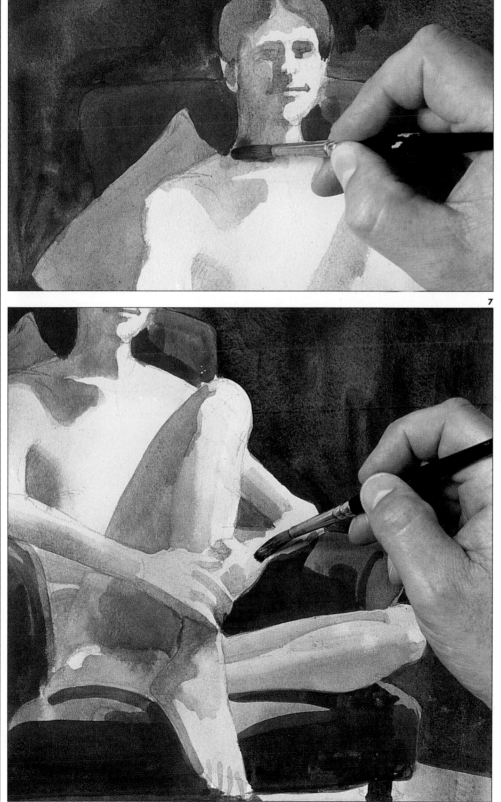

6 Concentrating on the figure for a bit – after all it is meant to be the focal point of the painting – start building up the shadows on the skin with a dilute mixture of burnt umber, jet black and yellow ochre.

7 Add a lot more yellow ochre into your wash and paint in the softer shadows, re-strengthening the stronger shadows at the same time. Repeat this process until you are happy that the mid-tones and shadows are of the correct shade. By working slowly in this way you gradually build up the tone in layers. This in turn creates great 'depth'. You do not have to worry about being too precise with your painting as this is more an exercise in depicting texture and tone rather than a true likeness.

8 Now re-paint over all the skin tones with a thin wash of jet black and yellow ochre. This will tie it all together, by softening the edges between colour changes, in preparation for switching to painting in opaque. With this mixture you can also paint over the light part of the floor – again to smooth colour changes and to make sure that there are no white bits of paper left showing through. Finally, before switching to opaque, use jet black and cadmium red pale to darken the base tone of the cushion and alizarin crimson to further darken the chair tones. Then allow your painting to dry totally.

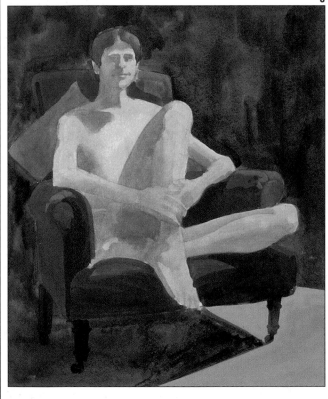

8

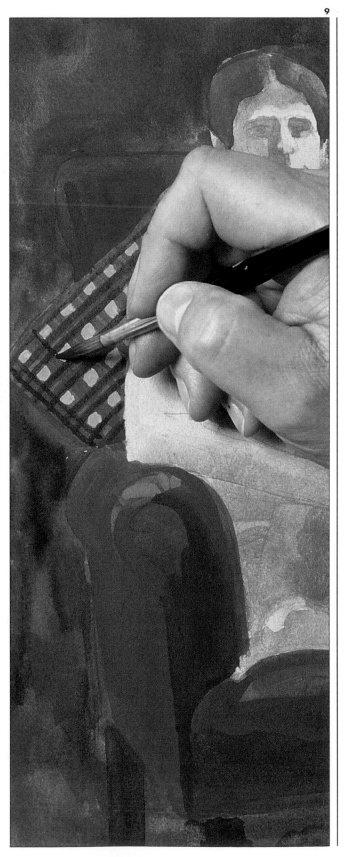

9

9 Now to use the gouache in a less dilute form which makes it opaque. Use a mixture of yellow ochre and jet black with a touch of cadmium red pale to paint opaque (much less water added) over the light floor area. Then use a few different variations of jet black mixed with cadmium red pale and permanent white to paint the tartan pattern on the cushion – obviously more white for the lightest areas and more black and red for the darker stripes.

10 Drop the jet black from your mixture and use just cadmium red pale and permanent white to add the rather harsh highlighted areas on the leather armchair. Start with the darker highlights and decrease the amount of red in your mix as you work towards the lighter areas. Allow this to dry and then add the purest parts of the highlights with straight permanent white. By working them up in this way you will get very vivid and sharp highlights that suit the nature of smooth leather.

11 Keeping with the same small group of colours for the moment, mix together cadmium red pale and jet black to create a deep skin tone with which you can re-paint the darkest shadows on the body. Then mix up a pale brown from a combination of yellow ochre, jet black and permanent white and mark in the light areas in the hair.

12 Re-create your light skin tone from step 4 – alizarin crimson and yellow ochre – but this time keep it opaque by

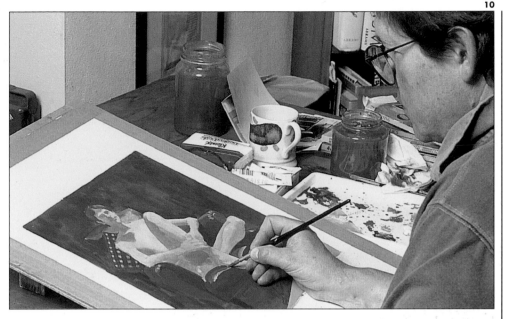

including very little water. Instead add permanent white to lighten it. Be careful not to add too much white as this tends to 'dull' the colour and, in this case, will make it too pink. A good tip is to add a touch of yellow whenever you use a large amount of white since this maintains the correct colour balance and prevents any 'dulling'. With light and dark variations of this mix you can now re-paint all the skin

tones, taking care to follow your original shadow and highlight areas. For the light expanses of flesh such as the chest, scumble in yellow ochre over the top. This broken

colour will lighten the tone a little bit while still allowing the pinker shades below partially to show through, giving the skin a wonderful translucency.

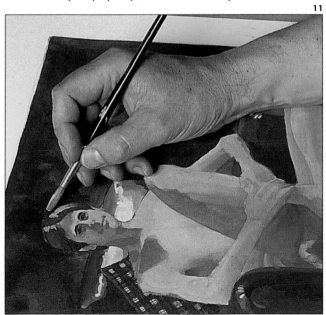

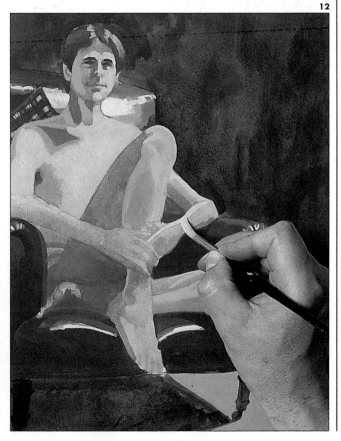

87

13 At this stage your painting is nearly finished. So you can now concentrate on adding the final details. If you are having difficulties in getting the skin tones right, overworking them will not solve your problem. Take heart that practise will make perfect in the end. Even the most experienced artists face problems in their work. It is part of the challenge.

Scumble some yellow ochre mixed with burnt umber down the closer leg to give the impression of hair and then use permanent white mixed with yellow ochre to paint in the highlights – paying particular attention to the face, hands and feet.

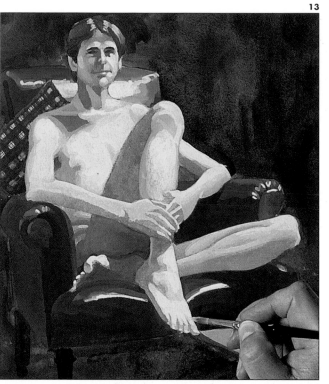

13

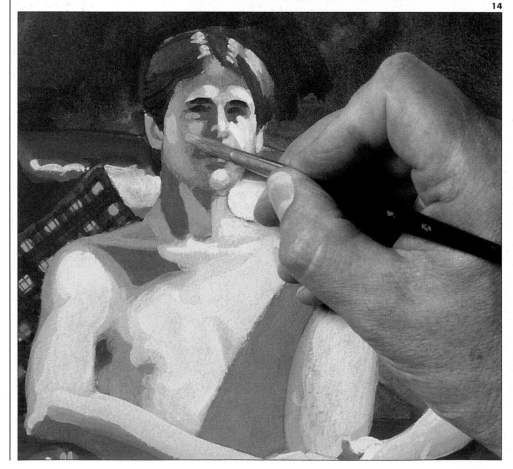

14

14 Finally, create a deep skin tone by mixing together yellow ochre, burnt umber and a touch of cadmium red pale and permanent white, and use this to re-establish the shadows on the face and neck.

15 That finishes the painting, so you can step back and admire your work. By now you should be only too aware that gouache has a tendency to dry much lighter than it appears when wet. So it is best to leave your painting for a few hours before you give it a final appraisal.

Since this project was probably your first attempt with gouache, try not to criticize yourself too much. As we mentioned earlier, gouache is a difficult medium to get to grips with. However, do compare your finished painting with the example shown below. Pay particular attention to the different textures you tried to achieve – the flesh, cushion and leather. Do they look like three distinct textures? If not, then practise painting small swatches on a scrap of paper until you get them right. This alone will put you well on the path to painting successfully with gouache.

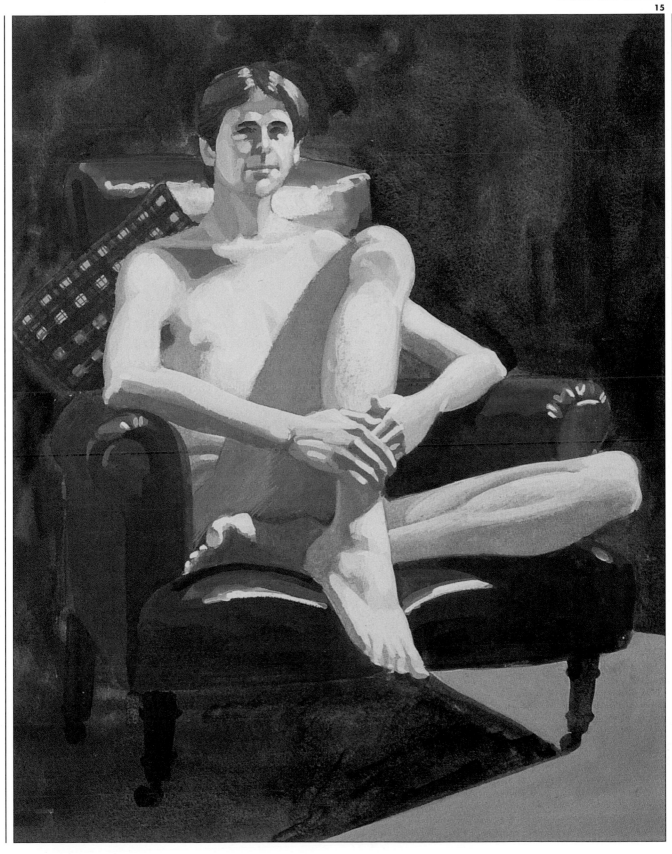

Chapter 6
Acrylics

In this chapter we explore a modern medium, acrylics. Synthetically made, acrylic paints were first developed in the 1920s and were intended for industrial use. Due to their weather resistance and fast-drying qualities, mural artists working in Mexico began to use them to paint huge propaganda pieces. However, it was not until the late 1950s that acrylics started to come into their own. A new movement, which was known as 'Pop Art', called for bold colours to suit its brash personality. The 'Pop' artist depicted the modern environment by using images from American popular culture – everything from soup cans to hamburgers. It was an experimental period, and discovering the creative potential of a truly modern paint medium added to the excitement. The paintings of Andy Warhol and Roy Lichtenstein soon gave acrylics a reputation for being extremely colourful, and on their introduction into Europe they were quickly adopted by artists such as David Hockney.

More recently, acrylics have tended to be used to mimic the effects of oil paints or watercolours. This is a shame because they have much to offer in their own right – in fact their true limitations are still not really known. And, if you are feeling bold and decide that you want to take acrylics back to their roots, there is nothing stopping you from creating your own mural to brighten up that rather boring outside wall.

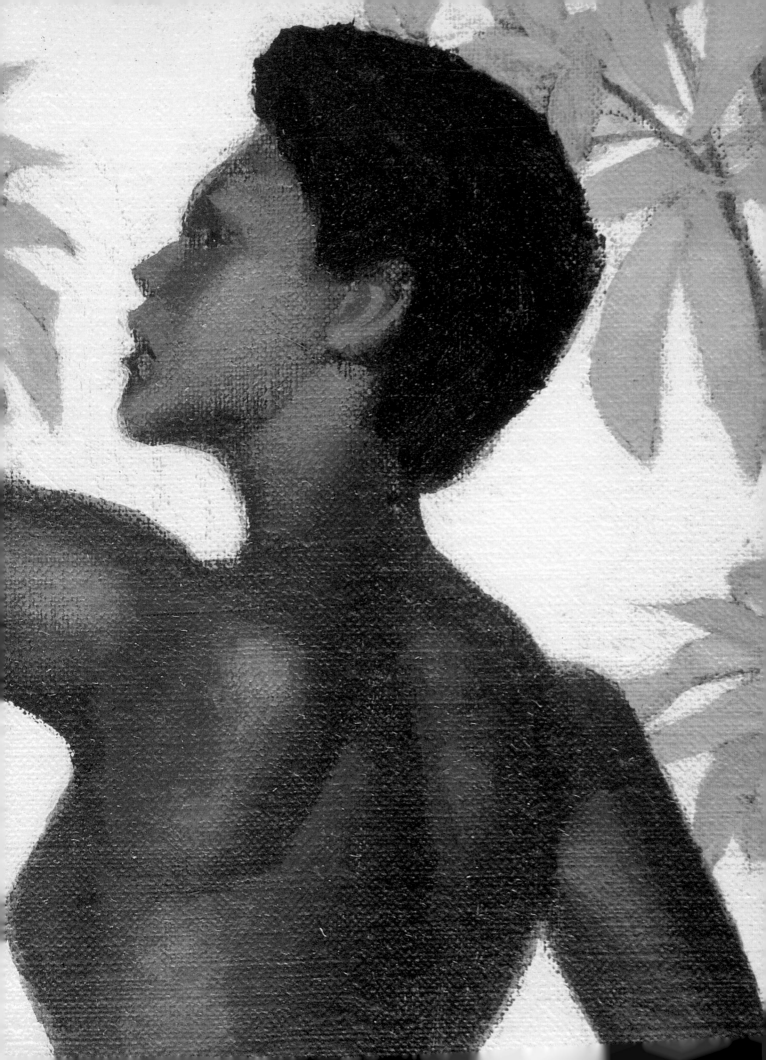

Materials

ACRYLICS

Paints

Acrylic paints consist of pigments bound in a synthetic resin and suspended in water. Acrylics can be diluted with water, but once they have dried on the support they are water resistant and are probably one of the most hard wearing and permanent of all media.

The choice of colours is vast, with all the traditional hues being readily available, but since they mix so well, a palette of about twelve basic colours is normally more than enough. Like oils, acrylic paints are available in both artists' and students' quality. Less costly PVA and vinyl paints are also sold especially for use on large areas, but the pigments are of a poorer quality. Artists' quality acrylics will never discolour with age, mix together extremely well, and are so flexible that a painted canvas could be rolled up and the paint would not crack. It is for this reason that some people even use them to paint designs on leather jackets. This versatility is half the fun of using acrylics.

Mediums

There are various acrylic mediums which can be added to the paint to produce different effects. The two main types of medium are those which make the finish more shiny or matte. They both make the paint more transparent and fluid, so are useful when glazing with thin, smooth layers. In addition to these, mediums are available for nearly any effect you can think of. These include ones which increase acrylic's adhesive properties, gels for thickening the paint, right through to retarders which slow the drying time down by several hours.

Supports

Acrylic paint can be used on almost any surface. The only ones to avoid are those which contain wax or oil since the paint will not adhere to such

a surface and may peel off once it has dried. For this reason, canvases or boards specifically prepared for oil paints should be avoided.

Canvases primed specially for acrylic paints are available, but a less costly alternative is hardboard. Depending on your preference, you can choose to paint on either the

smooth or the rough side. The surface can be sealed with acrylic medium or, if you prefer a white support, with acrylic gesso.

Brushes

Your choice of brushes will largely depend on the style and techniques that you use. If you tend to use a

watercolour approach, then use watercolour brushes; for an oil approach, use oil-painting brushes. Because acrylic paint dries so fast your brushes can be easily destroyed. Be sure to moisten your brushes with water before loading them with acrylic paint, to prevent a gradual build-up that could ruin them. During a painting session, keep your brushes in a jar of water when not in use, so that the paint cannot dry on them – and wash them thoroughly at the end of the session. Most artists find synthetic brushes made of nylon better for acrylics as they are easier to clean and are inexpensive enough to replace frequently.

Palettes

Palettes for acrylic painting are made of white plastic, which is easy to clean. Wooden palettes are not recommended as the paint gets into the grain of the wood and is impossible to remove. A special 'Staywet' palette has been developed which keeps the paints wet for days.

Techniques

ACRYLICS

Glazing

When you add acrylic medium to acrylic paint, it turns transparent and dries to a gloss or semi-gloss finish. This gives you an opportunity to try a kind of optical mixing called glazing. A glaze is a thin layer of transparent colour which is applied over an opaque, dry layer of paint; the glaze combines with the colour below to create a third colour – for example, blue glazed over yellow produces a greenish tint – but the effect is quite different from an equivalent physical mixture of the two colours. This is because the glaze, being transparent, allows light to reflect back off the underlying colour, creating a luminous effect.

Glazing is traditionally associated with oil painting, but acrylics are ideally suited to the technique; unlike oils they dry in minutes, and are insoluble when dry, allowing you to build up several glazes in a short space of time and with no risk of disturbing the underlayers.

To create a sample glaze (1), brush on a few broad bands of colour diluted with just a little water. When this is dry, dilute a second colour to a transparent consistency with acrylic medium and paint a few bands across the base colour, leaving some of it exposed. When the glaze dries, you will see three areas of colour: the two original colours, and an optical mixture where they overlap.

Glazing can be used to enhance layers of thick, heavily textured paint known as impasto (2). The thinned colour settles into the crevices in the paint, accentuating the texture – a useful technique for painting the bark of a tree or a weathered stone wall. Cover a small area with thick paint, allowing the brushstroke texture to remain. When dry, glaze over it with colour thinned with acrylic medium, forcing it into the crevices to expose the peaks.

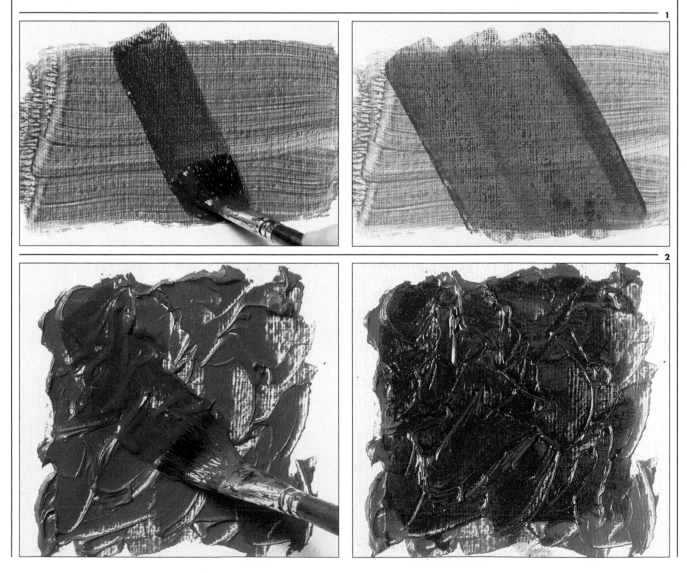

1

2

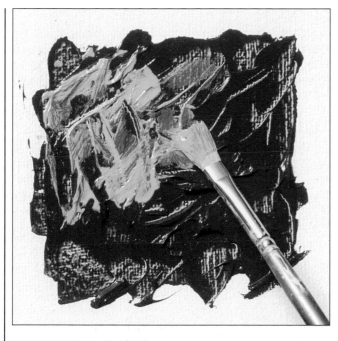

Scumbling

Another way of mixing colours optically is by scumbling. Here opaque or semi-opaque paint is laid unevenly over a dry layer of paint so that only parts of the under-colour are still visible. Lay down a small area of paint, applying it very thickly so that you get a rough, uneven surface. Allow this to dry completely, and then use another colour to lay some random brush marks over the top. The top layer picks up the contours of the paint below, yet still allows it to show through. Scumbling can also be used in a much more subtle way, with the top layer being put on more as a hazy mist to create the effect of a foggy mix of colours.

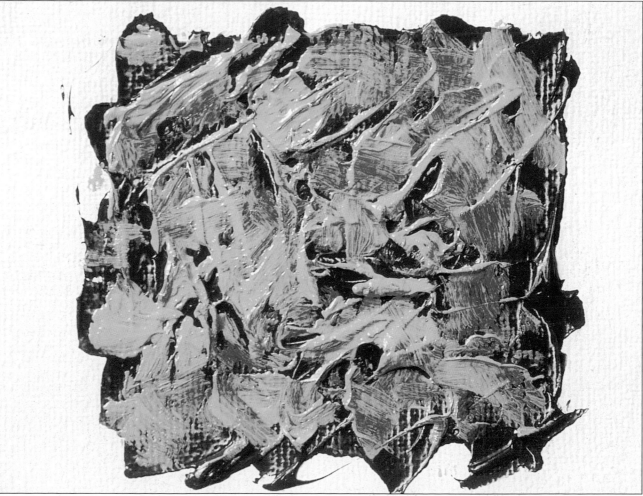

Wet into Wet

Diluted with plenty of water, acrylics can be used in the same way as watercolour paints yet still retain all the unique properties of the newer medium. To paint wet into wet, brush a coloured wash, well diluted with water, onto the paper. Immediately apply a wash of your second colour next to the first and allow the two colours to meet, blending them slightly with the end of your brush. You will find that adding a little matte or gloss medium to the paint will give you greater control over the washes.

Blending

Because acrylics dry so much faster than oils, subtle graduations and blendings of colour are more difficult to achieve. However, the addition of a little gel medium to the paint gives it a consistency nearer to oil paint and prolongs the drying time.

Another alternative, shown here, is to rough-blend using short, dense strokes. Working quickly, before the paint dries, apply the two colours next to each other and 'knit' them together by stroking and dabbing with your brush at the point where they meet.

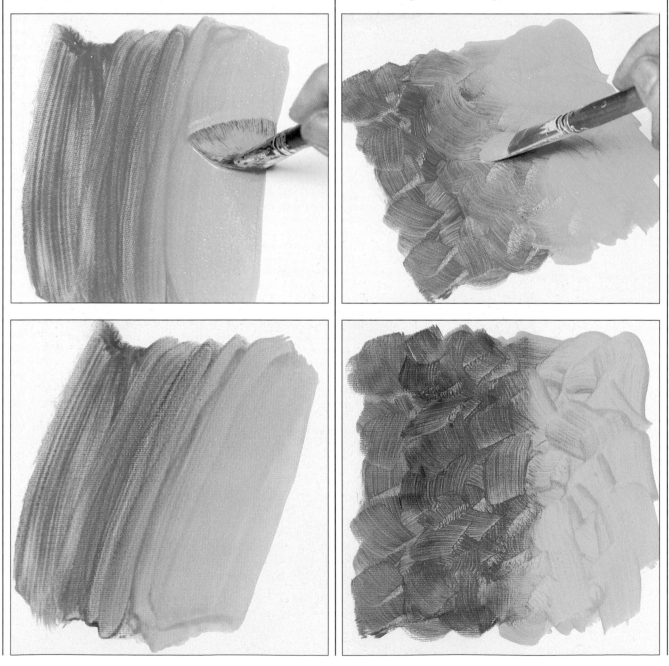

Sgraffito

To create interesting textures and highlights any sharp tool can be used to scratch lines into acrylic paint while it is still wet. Experiment with different tools – palette and painting knives, the end of a brush handle, even your fingernail – to discover the variety of textures and patterns that can be achieved. You can also scratch through a layer of paint to reveal the underlying colour – as the artist has done here.

Lay a base coat then, when it has dried, paint over it in another colour *(1)*. We used two tones of the second colour, but one tone is sufficient. While the paint is still wet, scratch tiny marks all over it with a palette knife *(2)*. Keep the pressure light as you do not want to scratch through the first layer of paint or damage the surface of your support. You can see how the initial layer of paint shows through, creating an interesting, two-toned textural effect.

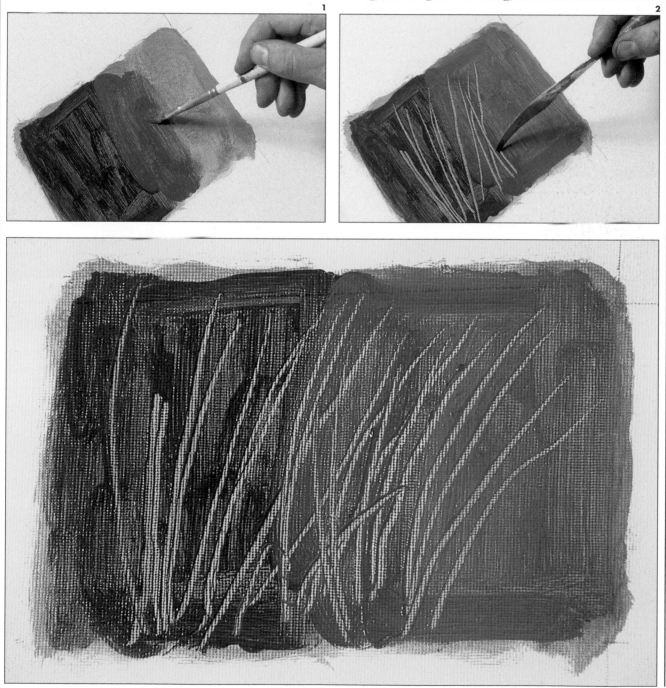

In the Shadows

ACRYLICS

For this particular image we did not require a live model as it was 'one the artist prepared earlier'. The room was ready for decoration so not only was it empty but the furniture was draped in cloth to protect it from any splashes of paint which inevitably occur when redecorating. Outside the window is a large tree and as dusk fell, the late evening sun shone through the leaves casting shadows across the room which created abstract patterns. This appealed greatly to our artist who called upon his wife Lydia to pose naked among the shadows, creating an image with a strong surreal quality. Unfortunately not all of you will be lucky enough to have not only a beautiful partner to hand, but one who is obliging enough to pose at a moment's notice. She also happens to be a professional cook – some people have all the luck!

Anyway, the fleeting light of this moment at dusk was captured in a photograph. The fact is that a camera does play an important part in any artist's life and as you continue to paint, you will find yourself looking around all the time and seeing scenes – whether everyday objects, or on exotic trips abroad – which will translate well into paintings. Even if you do not paint from them immediately you will be laying the foundations of a wonderful source of reference material which will prove invaluable as time goes on.

This rather abstract scene allows a certain amount of freedom as the brushstrokes are loose – probably the most fun way to use acrylics – and the painting is built up gradually, giving you time to make decisions as the painting progresses. The colour mixes are initially fairly thin, but the final layers of paint contain no water at all. A long-handled paintbrush will mean that you paint at a certain distance from the canvas which will encourage you to create loose, bold brushmarks which are always credited to the expressive artist.

1 As with most paintings your first step will be the initial outline drawing. This is often rendered in pencil but, because it will not show through in the finished piece, it is possible to use a graphite stick. You will find that a detailed sketch, mapping out areas of tone, will act as an invaluable guide to the painting as you progress.

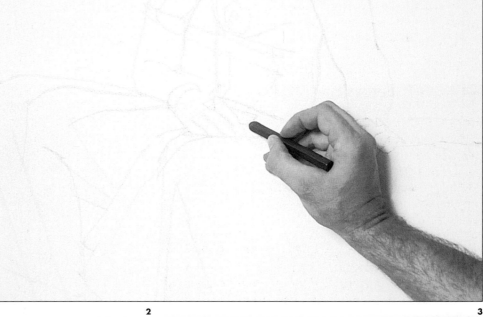

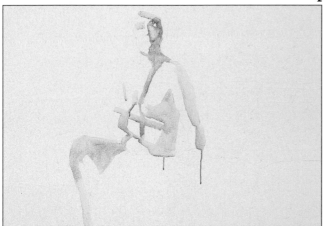

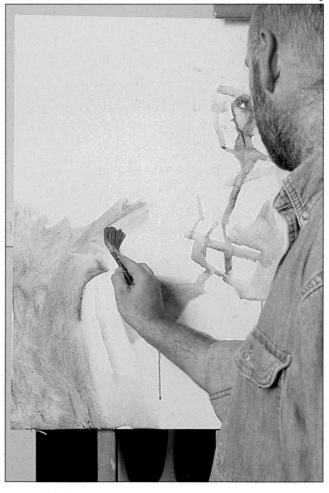

2 Start off with a palette that consists of cadmium red, raw umber, cobalt blue, Payne's grey, yellow oxide and Turner's yellow. Squeeze out a little of each so that you can vary your mix as you go. With a no. 8 flat, hog hair brush pull in some cadmium red, Payne's grey and Turner's yellow and add a lot of water. This is for the first coat of the dark shadows. If you are working on an upright easel – as the artist is here – this watery mix will run but do not worry as it can be covered over later.

3 This next stage is nice and loose as, once again, it is only the first layer of the background. Switch to a 1½ in. (4cm) decorator's brush and with Payne's grey diluted with lots of water loosely cover the darkest, shadowed areas of the background. This will give you a good base to work up from.

4 Change back to the no. 8 brush and darken the previous mix by adding a little cobalt blue and Turner's yellow. Continue to paint over the darkest areas of the background varying the strokes as you go and employing a random style to maintain a loose feel. Mix a little ivory black and yellow oxide with some water and paint in the hair and add some extra strokes to the background.

5 With the same brush and a mix of sap green, yellow oxide and Payne's grey, start to paint in the foliage outside the window. Although this mix should be fairly thin, it does not have to be as watery as the previous washes as this is the second layer of paint. As you paint remember to use bold, random strokes to keep the work loose and expressive.

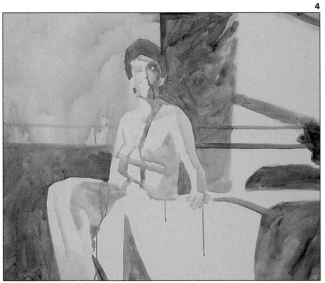

4

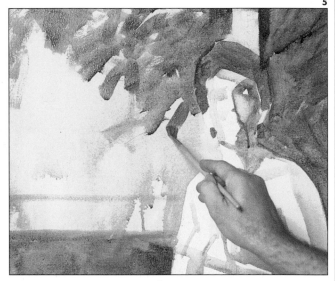

5

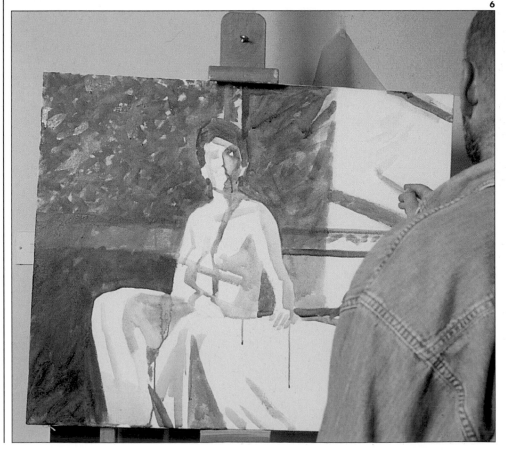

6

6 You are now going to paint over the first coat of the background which dries quickly being acrylic. Using Payne's grey and slightly less water than in step 3, but the same no. 8 brush, paint over the dark shadowed areas and add the folds of the material. With a fresh mix of Turner's yellow, yellow oxide and some white with a little water, paint in the pale wall at the back.

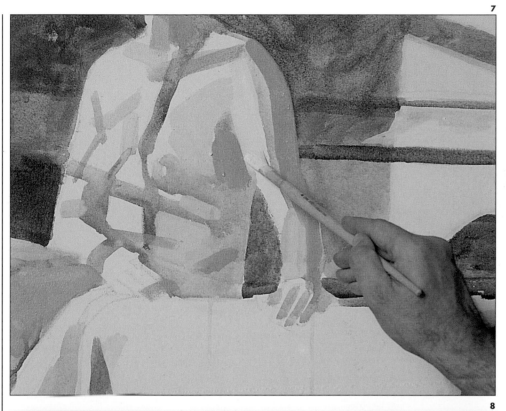

7 Now, using white paint diluted with water, paint over the material. Although this might look a little 'dirty' due to the fact that the brush has not been cleaned between mixes, do not worry as this is really just to get some paint on to this area. Into the white add a little cadmium red and Turner's yellow to create a mid-flesh tone to start to liven up the body.

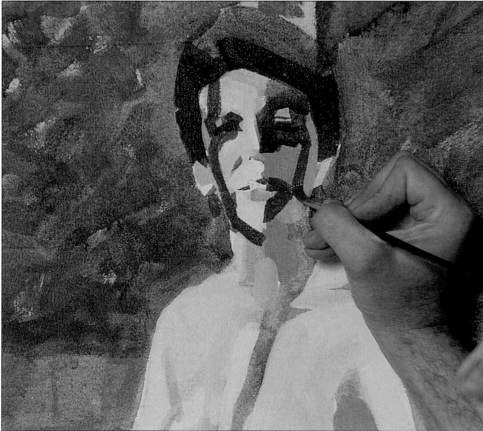

8 Now you have covered the whole canvas in paint so this gives you the ideal opportunity to step back and take an overall view of the painting to decide which part to work on next. The figure is definitely looking a little flat, so with the same brush and a mix of cadmium red, raw umber and Payne's grey, start to paint in the darkest areas of the flesh, including the shadows which fall across the face.

101

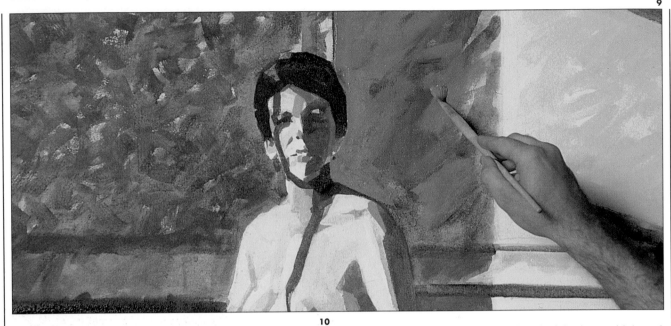

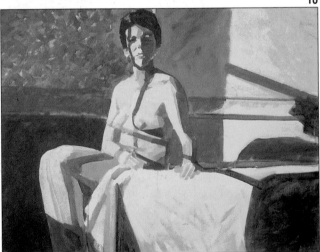

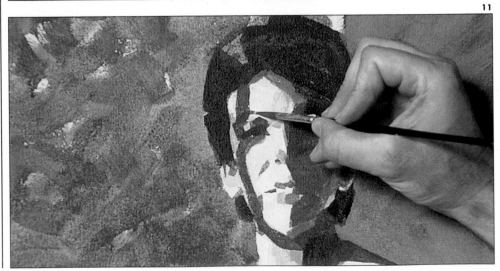

9 Continue to darken all the shadows of the face and down along the body. When these are complete mix some yellow ochre and ivory black with a little white and very little water to paint in the 'dirty' ochre shade in the background.

10 To the previous mix add plenty of cobalt blue and paint in the shadowed area in the front, and to the right, of the picture. With some Payne's grey and a dash of water, paint over the strip of dark wood under the window and then dilute it right down with lots of water to paint in some more shadows in the cloth. Then paint over the cloth again with titanium white and water to soften them. To the titanium white add some Turner's yellow and add the highlights on the chest of the figure.

11 Continuing with the previous mix, paint over the light wall at the back, remembering to keep the brush strokes nice and loose. Having worked up the surrounding areas, the figure has started to fade into the background. Change to a ¼ in. (0.5cm) flat brush and with the original mix of cadmium red, Payne's grey and Turner's yellow with a little water go over the dark shadows of the figure, including the hands and the face, eyes and lips. Into this mix add a little ivory black and paint in the hair that shows through from behind the head.

12 Switching back to the no. 8 brush and the mix for the leaves – sap green, Payne's grey and ivory black with hardly any water – 'attack' the foliage with big, expressive brushstrokes. Start at the top of the canvas and work downwards but do not cover the bottom half. This is because you are going to place a strip of masking tape along the straight edge of the window frame.

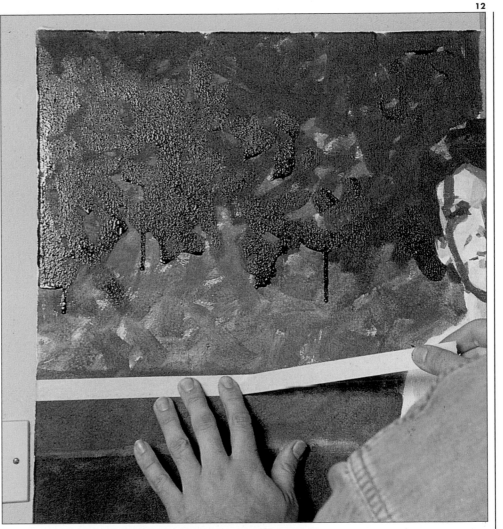

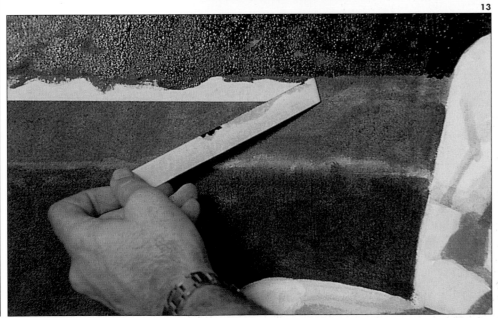

13 This will enable you to continue with your random strokes right down to the bottom without having to cramp your style. As you can see here the paint has gone all over the tape, but when you peel the tape away you are left with a perfectly straight and clean edge. One word of warning is to wait until the paint is dry before you peel the tape off, to avoid any runs.

14 Masking tape is not only useful for obvious straight edges. It also makes life much easier when you are working on an area where there are stripes, or small areas of different colours and you do not want to lose the freedom of the brush strokes. So, return to the figure and place the tape over areas that you want to keep clean and with Turner's yellow and titanium white paint in the palest areas of the flesh, where the sunlight falls.

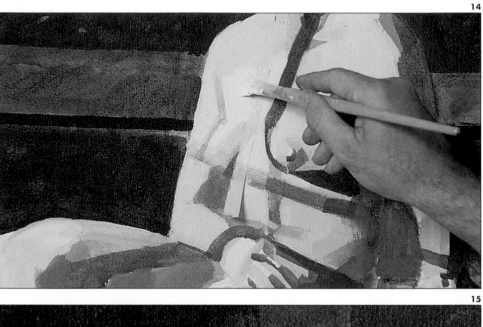

15 The painting is really coming together but the face could still do with some more work. Switch to the ¼ in. (0.5cm) brush and with some cadmium red, Turner's yellow and a dash of titanium white fill in the areas of white on the face to warm them up a little. With some cadmium red, darken the nipples and paint in the lips. This now makes the teeth too bright and creates too big a contrast so mix a little Payne's grey and yellow ochre, and take them back.

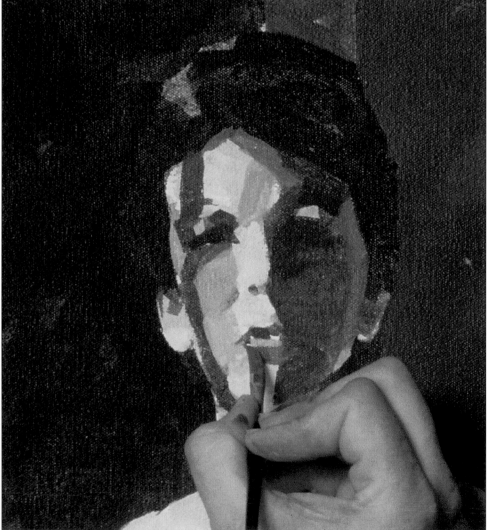

16

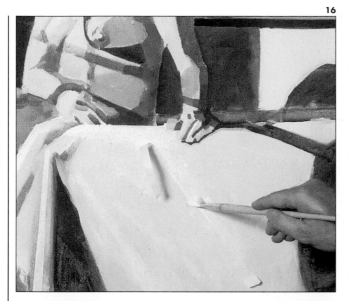

16 Although the painting looks finished, the white material is looking a little drab and grey so it needs to be 'cleaned' up. Once again the masking tape technique is perfect. Simply lay strips of the tape randomly over the grey folds of the cloth and with some neat titanium white and large brushstrokes paint over the area, pulling the tape off as you go to see if anymore needs to be added.

17 With some sap green and Payne's grey paint some random dabs over the leaves as a final touch. A painting like this does not really have an obvious point of completion. You may, if you wish, go over all the tones of the background again to give an even more textural feel to it. However, resist overworking the painting, after all the main point of this project was to show you how to be freer with your brush strokes. So even if you followed this project religiously it should still hold your own individual stamp. We also hope that this encourages you to express yourself and in turn help you to develop your own unique style.

17

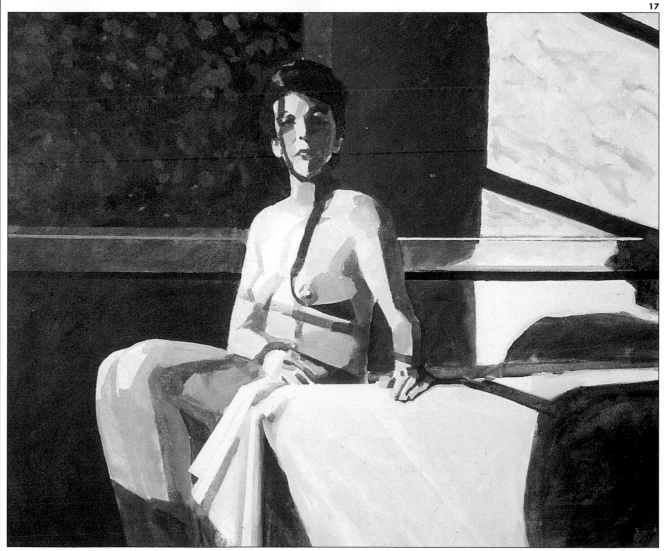

Female Body Builder

ACRYLICS

For this project we thought it would be a change to paint a female body builder. We were lucky enough to know this model as she worked at a local gym where we used to be members. She had also won several competitions in Europe and the UK. Not all of you will have a contact like this, but do not forget the abundance of health and fitness magazines which are readily available these days and were used for our project on page 54. Although we thought it would be a challenge to depict a well-toned body we still wanted to retain a degree of femininity. Therefore, instead of a normal bodybuilding pose with flexed muscles – which would have been impossible to hold for any length of time – we chose a position which shows off the contours of the body.

When our model arrived the sun was shining through the window, so she posed in front of the light to emphasize her silhouette with her dark skin against the bright light. We took photographs too, because, as the sun moved, the light was lost. The aim of this project is also to try and encourage you to look at an image and interpret it in your own way. In other words to show you how to use your reference as a starting point in developing your own individual style.

1 Instead of a normal pencil to map out the initial sketch, a clutch pencil with a 3B lead – which is nice and soft – is used. A clutch pencil is a useful tool to invest in. It has the 'body' of a pencil, but with 'claws' at the head which open out to accommodate the drawing material, from the very finest of leads right up to chunky sticks of charcoal.

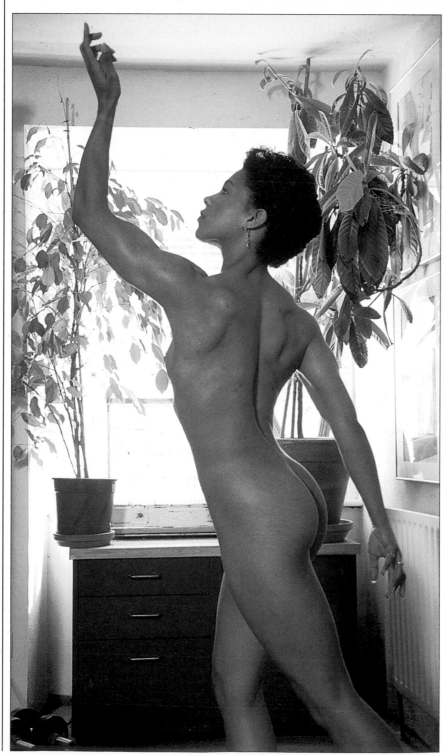

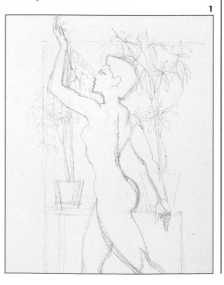

2

3

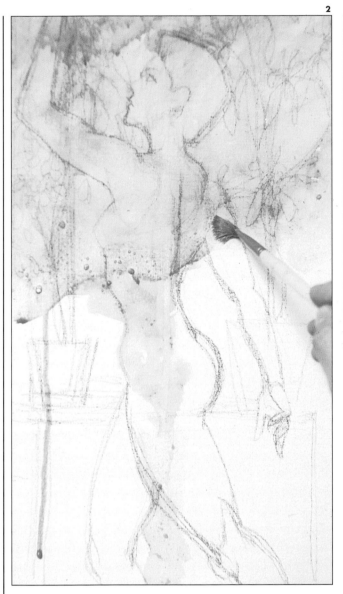

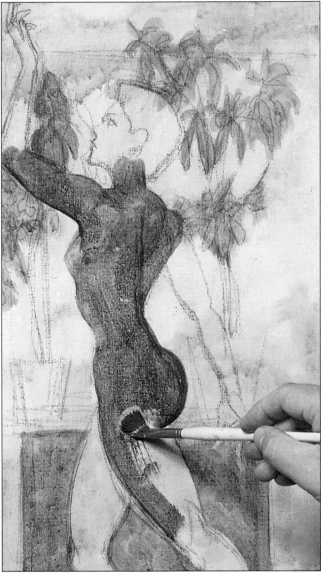

2 With a mix of viridian green, cadmium red and a touch of yellow ochre, with lots of water and a no. 4 flat bristle brush, paint over the whole surface of the canvas putting two layers on to the box. This will eventually give the painting an overall feel of harmony, as well as a green cast which will form the base colour of the whole image.

3 Now add some water to a little viridian and paint in the leaves. With a less dilute mix of viridian, cadmium red and yellow ochre than you used for the underpainting, go over the whole of the figure, including the head, once more.

4 Returning to the box, mix some viridian green, cadmium red, cadmium orange and black with a little water and completely fill it in to make it look totally solid. Changing back to a mix of viridian, cadmium red and yellow ochre, paint loosely over the background once again keeping to the no. 4 brush.

4

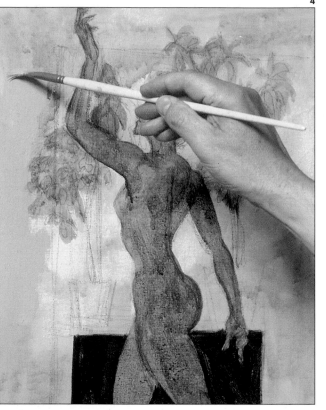

5 Paint the flowerpots with your no. 4 brush and the same mix as you used for the box in the previous step, but with a little more red added. To this mixture add some more water and change to a no. 6 round sable brush to put in the fine details of the branches. You do not have to use a sable brush, a less expensive soft hair brush will do the job.

5

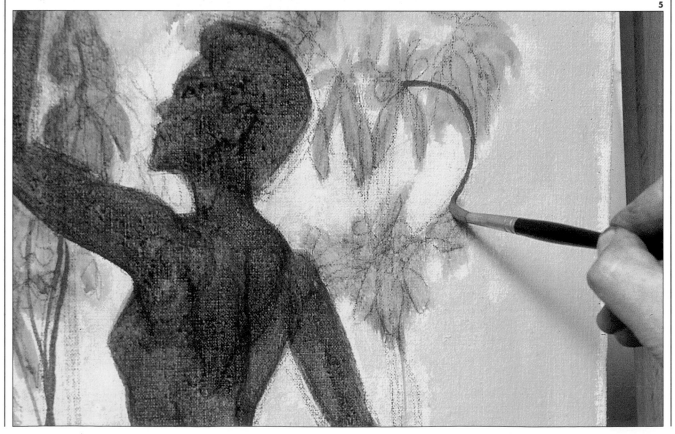

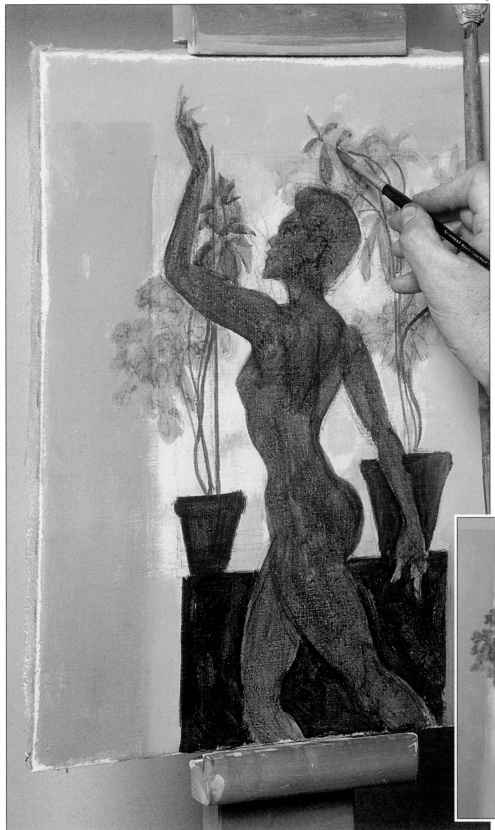

6

6 With some viridian and white, switch back to the no. 4 brush and start to fill in the shadowed area across the top of the painting. Add a little yellow ochre, and paint in the left-hand area, starting at the top. As you work down include some cadmium red and cadmium orange to warm it up where it catches the reflection of the box. Switch back to the no. 6 brush and with a mix of viridian and a little water, paint over the leaves, paying more attention to detail. For this type of work it is much easier to use a mahlstick to help steady your hand.

7 The window area where the light shines through is looking rather dreary. So sticking with the no. 6 brush, mix a little yellow ochre into some white and paint around the figure and the plants, still using the mahlstick to keep you steady. The reason for adding a little yellow ochre to the white is to warm it up. A stark white would have created too big a contrast to the rest of the painting.

7

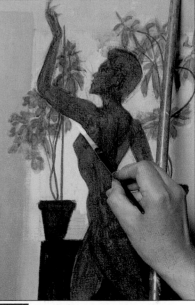

8 As the background and the other elements of the painting have received all the attention so far, the figure is now looking very insignificant. With a fresh mix of viridian green, cadmium red and cadmium orange, switch back to the no. 4 brush and paint over the figure. The first mix should have a higher ratio of viridian which will keep the tone dark. However, as you proceed you want to lighten the mix for the highlights in the flesh by adding more orange and red. Work this wet in wet which will give you a blend of colours rather than any harsh lines.

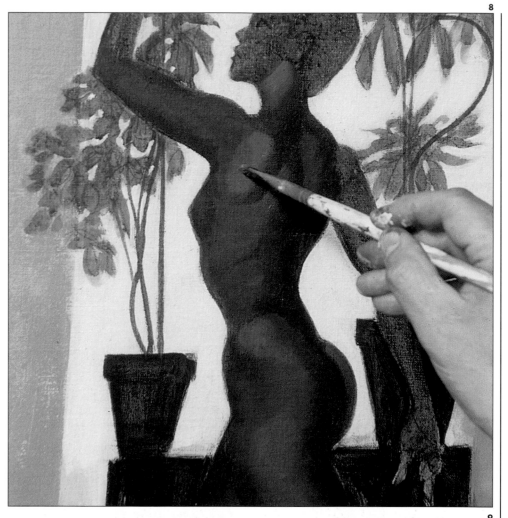

9 On standing back and referring back to the original reference, the bottom looks a little large. Even though the model is a bodybuilder and extremely muscular it is definitely exaggerated and throws the body out of proportion. To correct this, return to the light mix of white and yellow ochre and the no. 6 brush and paint over the curve of the buttocks to slim them down. This also shows how good acrylics are at covering one colour with another, even light over dark.

10 With the bottom greatly improved, you can return to the head. Change to the no. 4 brush and with a mix of cadmium red, viridian green and black paint in the hair.

11 The leaves need to be 'knocked back' as they are beginning to look too strong. They are a similar tone to the figure and are therefore demanding too much attention which distracts from the focal point. To counteract this, switch to the no. 6 brush and paint over the leaves with a mix of white, viridian and yellow ochre so that they now match the light and tone of the window. Remember to keep your hand steady with a mahlstick and not to paint over the leaves which fall in the shadow on the left-hand side.

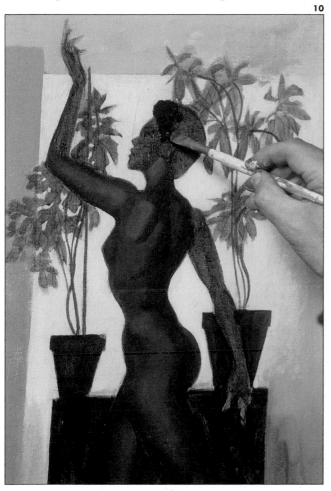

10

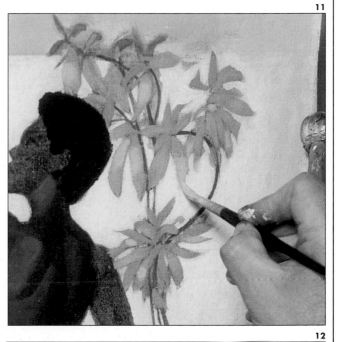

11

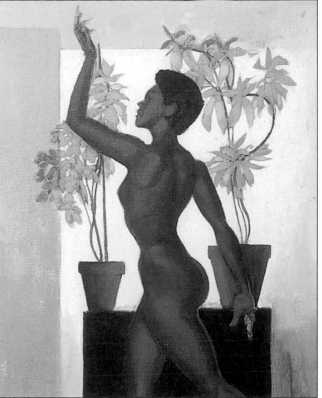

12

12 The flower pots require modelling as they look a little flat, so with the same brush and a mix of viridian green, cadmium red and cadmium orange, with the emphasis on the orange, lighten up the sides closest to the body where they catch the light. With the same mix, but with more green to darken it, paint in the whole of the figure again, including the face and the arms. When you have done this you will notice that the box is not strong enough to hold the figure, so to the same mix add some black and really darken it down. As the painting is now in its final stages, this is a good point to stand back and take an overall view of things before proceeding any further.

13 Switch back to the no. 6 brush and with the usual mix of viridian green, cadmium red and cadmium orange, paint in the edge along the top of the box. To achieve a straight edge hold the mahlstick horizontally over the box and away from the painting in the usual way, but instead of your hand, rest the ferrel of the brush against it as you draw it across the surface. To paint where the top of the box is reflected in the light use a mix of cadmium orange and white. Returning the mahlstick to its normal position and to the usual mix (as at the beginning of this step) but with the emphasis on the orange to make it lighter, start to add the highlights to the figure, as well as the side of the face and the ear.

14 Continuing with the mahlstick and the previous mix lightened further with the red and orange, dry brush over all the surface points – those closest to the viewer's eye – which will make them stand out even further and give extra definition to the muscles. With a new mix of cadmium orange and viridian green, paint in the palm of the lower hand.

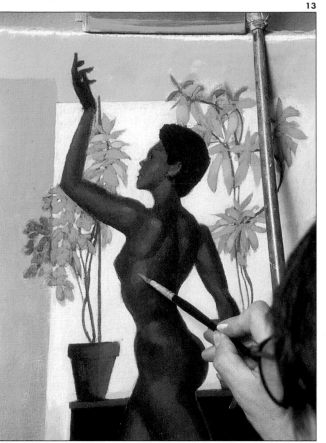

13

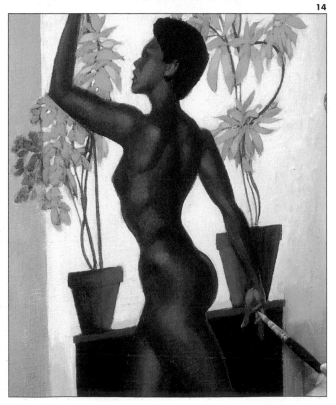

14

15 Move up to the other hand and, with the previous mix, paint in the inside of the fingers and parts of the palm that are showing. Before the painting is finished, lighten your familiar mix with some more cadmium orange and paint over the highlights of the figure once more, not forgetting the face and the ear. One more point before finally putting your brushes to rest, namely, the out-stretched hand which looks slightly ragged around the wrist. To correct this simply mix some white with a little yellow ochre and tidy up the offending edges.

You may now stand back and assess your work. If you have followed this project exactly you will see that the artist has emphasized the curved sculptural shape of the figure which in reality has a fairly straight line to it. Notice how this is achieved by balancing the curves of the body against each other, for example the buttocks against the belly and the curve of the back against the midriff. This means that this painting is the artist's personal interpretation of the subject matter, putting across his reactions to the model and her surroundings.

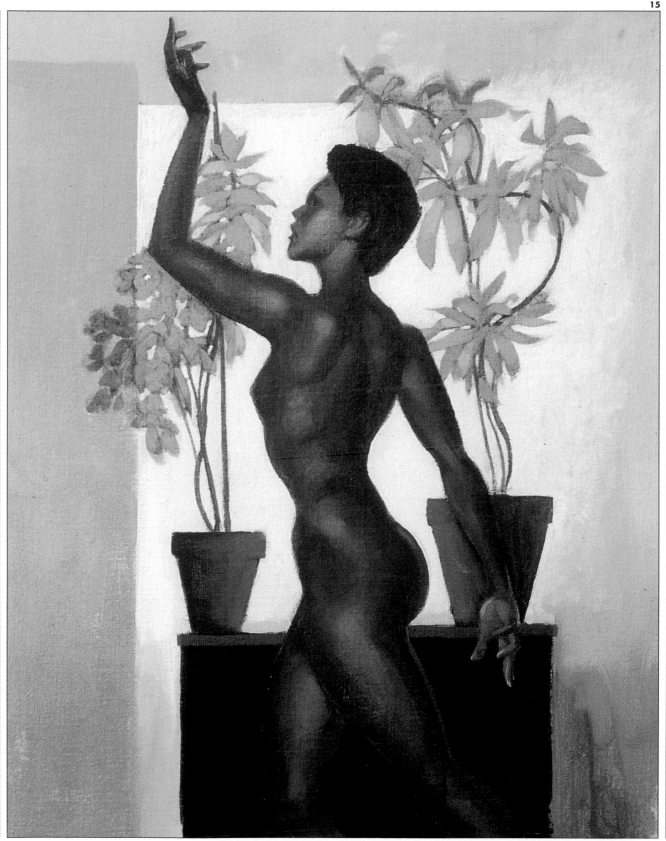

Chapter 7
Oils

Of all the painting media available, oil paint is perhaps the most popular of all. This is largely due to its great versatility, allowing virtually any subject to be tackled with a wealth of different techniques at your disposal. A large number of the world's greatest masterpieces were painted in oils; and even in today's high-tech world they have lost none of their appeal.

Oil paints were first developed in the 15th century by the Flemish painter Jan van Eyck (*c*.1390-1441) to overcome the problems of tempera, which was then the most common painting medium. Tempera paints were made by mixing powdered colour – often obtained by boiling fruits, drying them and then grinding them to a powder – with egg yolks and water. When the paint was brushed on, the water evaporated and the egg and pigment dried within minutes to form a hard, matte finish that was liable to crack.

Van Eyck discovered that by mixing pigments with linseed oil, the dried paint surface was more elastic. Furthermore, the paint could be applied in transparent layers which enriched the colours and gave them a wonderful luminosity. Since then, generations of artists have discovered the tremendous versatility of oil paints. Whether used thickly for a richly textured effect, or in thin, delicate washes, oils offer a wealth of creative possibilities; even the most experienced artist is never likely to tire of this medium.

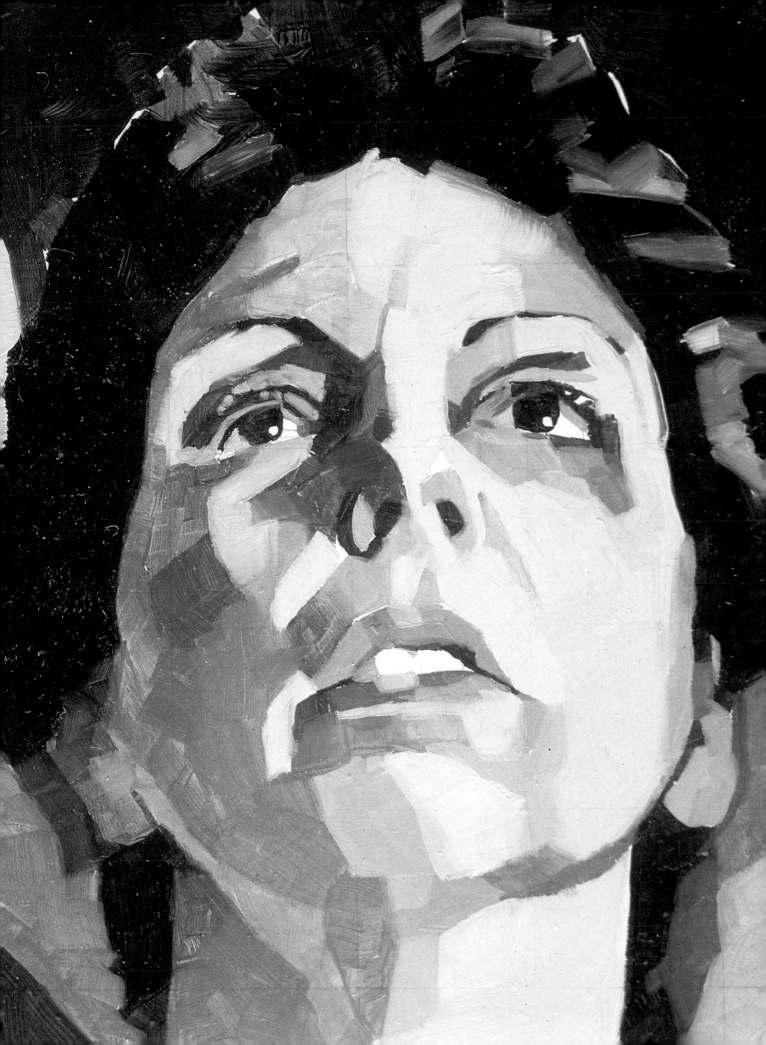

Materials

OILS

Paints

Oil paints come ready prepared in tubes and are made up of pigments suspended in an oil binder such as linseed or safflower oil and occasionally poppy oil which is quicker-drying. There are two grades of oil paint available: artists' and students'. Both are available in a wide range of colours. Although the artists' grade contains more pure pigment and is therefore more expensive, the students' grade is perfectly adequate and is fine for practising with. The only problem is that not all the colours are obtainable in the students' range, but the two types will mix quite happily in a single painting.

Painting Mediums

Although oil paint can be used directly from the tube, more often a medium is added which alters the consistency of the paint and makes it more malleable. There is a variety of mediums available and they all affect the drying rate, flow and texture of the paint in different ways. The most common is a blend of 60% linseed oil and 40% turpentine or mineral spirits, but be sure to buy purified or cold-pressed linseed oil which does not yellow with age. Other mediums include beeswax which dries slowly and gives a matte finish, and gels (synthetic resins) which provide extra body.

Supports

Oil paint can be applied to practically any surface, from canvas – the most commonly used – to wood and hardboard. Stretched canvas provides the perfect support but it is expensive and there are less costly alternatives. Ready-primed canvas boards are convenient to use, and oil-sketching paper, available in pads, is handy for outdoor work. Hardboard, and even cardboard, are inexpensive and provide a good surface but they must be sized on both sides to prevent warping and then properly primed.

Brushes

The best oil-painting brushes are made of bleached hog's-hair bristles. They are strong enough for the thick consistency of oil paint and hold the paint well. There are also soft brushes (sable are the best, but synthetic versions are available and are much less costly) which create smoother, softer strokes and are good for details. They are all available in four basic shapes: filbert, flat, bright and round, the latter being the most versatile. It is always a good idea to buy a variety of sizes, whichever type you choose.

Other equipment

There is an array of accessories to choose from, but the most useful will be a wooden palette. Dippers (small metal cups to hold oil and turpentine or mineral spirits) can be clipped to your palette, but jars are just as good. A mahlstick (a long cane with a pad at one end) is useful for steadying your painting arm when adding fine details. Finally, if your budget will allow you, an easel is an investment that you will not regret.

Techniques

OILS

The following six examples are not actually techniques, but they illustrate the various effects that brushes of differing sizes and substance will make on the support.

1 A 1½ in. (4cm) flat brush. This brush would normally be used for varnishing a finished painting, but it is also extremely useful for filling in extensive areas of colour in the initial stages of a large painting.

2 A ½ in. (1cm) flat, bristle brush. This brush is good for applying short dabs of colour, useful in describing form and texture.

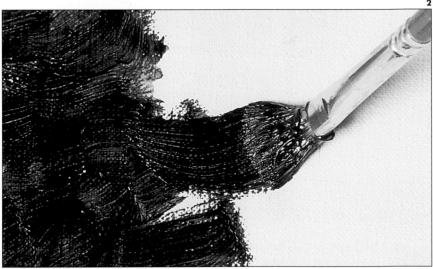

3 A ½ in. (1cm) flat, soft hair brush. Soft brushes are used for subtle blending and for applying thin glazes of colour. Note how different the marks are to those in the previous example.

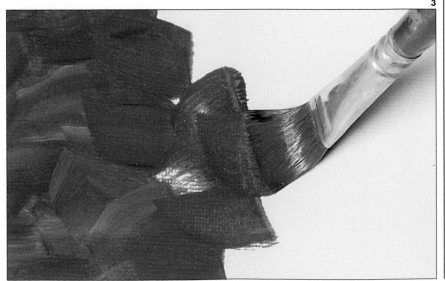

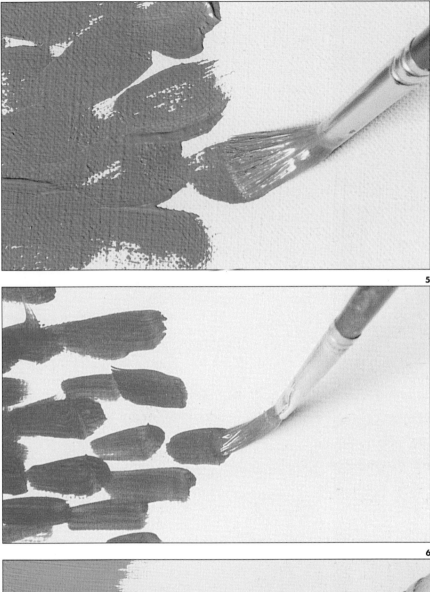

4 A no. 4 round brush. Not essential, but a useful brush for painting very fine strokes and details.

5 A ⅛ in. (0.3cm) flat, soft hair brush. The long bristles of this brush make it sensitive to pressure, allowing you to easily alter the brush mark.

6 A large, round bristle brush. This type of brush holds a lot of paint so is good for working loosely and for underpainting.

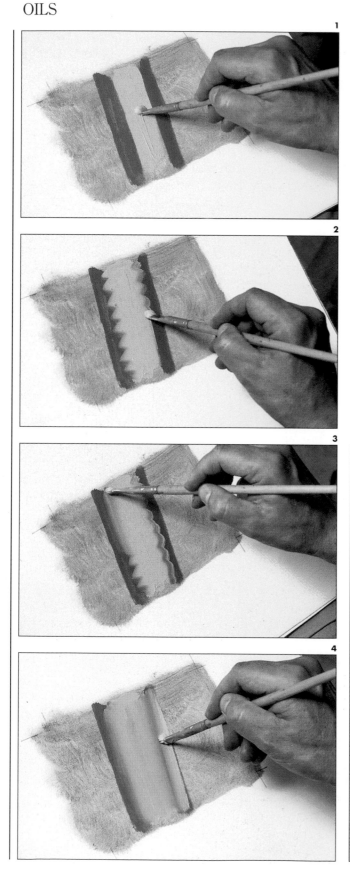

Blending

The following sequence illustrates several blending techniques within the one painting.

Start by laying a base colour and when it has dried paint two parallel lines in one colour, and a lighter tone between them *(1)*. Pull your brush in a zig-zag motion down each side of the centre band to create some spontaneous wet in wet rough-blending of colour *(2)*. The harder you press down on the bristles the more the two colours will merge. This technique is particularly associated with *alla prima* painting, which is where a work is completed in one sitting.

Many artists, however, prefer a softer blending of colours in their paintings. This is done by gently running your brush up and down where the colours meet *(3)*. They are slowly blended together to create a smooth gradation of colour. The light reflection to one side is painted on fairly dry and dragged up and down through the existing paint *(4)* to create an instantaneous blending of colour down its edges, while allowing its true colour to remain where it was painted thickest.

Finally, a band of light paint is applied down the centre, and a dry brush is used to drag it into the background form *(5)* giving a very smooth transition of tone which completes the cylinder.

Spattering

Spattering is when paint is flicked off a brush to create a shower of tiny droplets.

Lay a base colour in a light tone and, when it has dried, load a stiff brush with a darker tone and run your thumb across the bristles. This will cause the paint to fall as a random spray onto your support. The distance you hold the brush from the support will effect the size of the spray, as will your choice of brush and the consistency of the paint.

Painting Knife

Because the consistency of oil paint is so wonderfully thick, it is possible to create a whole range of textural effects with the use of a painting knife. Using the paint undiluted, scoop some of your chosen colour onto the end of a small painting knife. Using the flat of the knife, cover the area by drawing the paint across the support with irregular strokes. If you choose to use two colours repeat, using the same technique. The second colour can then be dragged into the first colour to partially mix them.

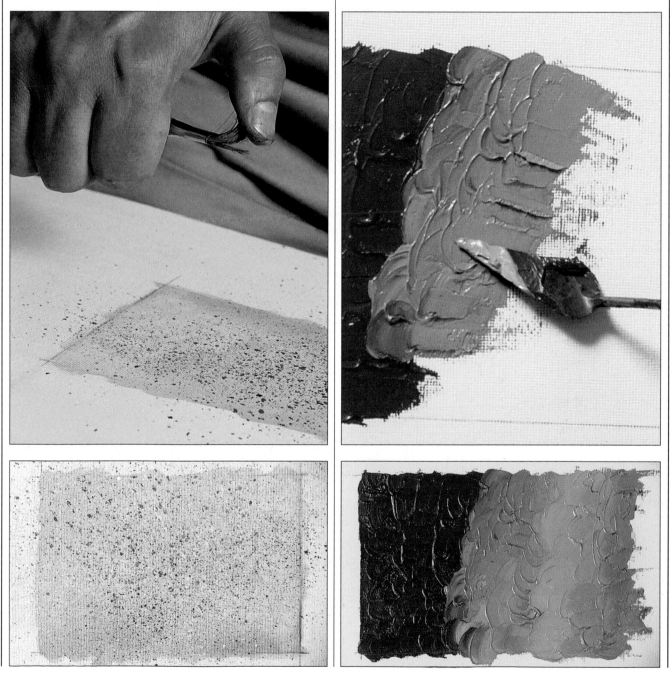

Lydia

OILS

The unusual composition of this painting was chosen not only to avoid you thinking 'oh no, not another naked body'! But also to add a further dimension to what is a classic pose. At the same time an obvious connection can be made between a skeleton and the nude figure. This is a very flattering pose for both men and women because, when the elbows are raised to the shoulders and bent behind the head, the whole body – as well as the arms – becomes stretched and slightly elongated, which in turn gives more definition to the muscles. The head is also tilted back slightly which shows off the neck beautifully. So now you know why this pose is so popular in glamour magazines!

The skeleton, as you can see from step 11, is taken from a medical book with a fold-out section. Such material is always useful which is why it is important for you to build up your own reference library. Secondhand book shops are always worth visiting, not only because they

offer good value but because, like the medical book we used here, they are full of more obscure and interesting subjects. Another good source for reference material are postcards and greetings cards, so always keep your eyes open.

In this project the emphasis is on tone rather than colour. The choice of hues – thirteen in all – have been chosen to allow you to mix a wide variation of tone without great variations in colour. As you mix the paints never take over the whole of the blob of paint. Always leave a little of the original on the palette so that you can return to it without having to start again and possibly never get an exact match. In fact it is a good idea to investigate the possible range of tones you can mix with this palette. You will be surprised by the variety and it will help you to mix the tone you want quickly, at will. If, however, you like to live dangerously, just pick up your brushes, throw caution to the wind, and go for it!

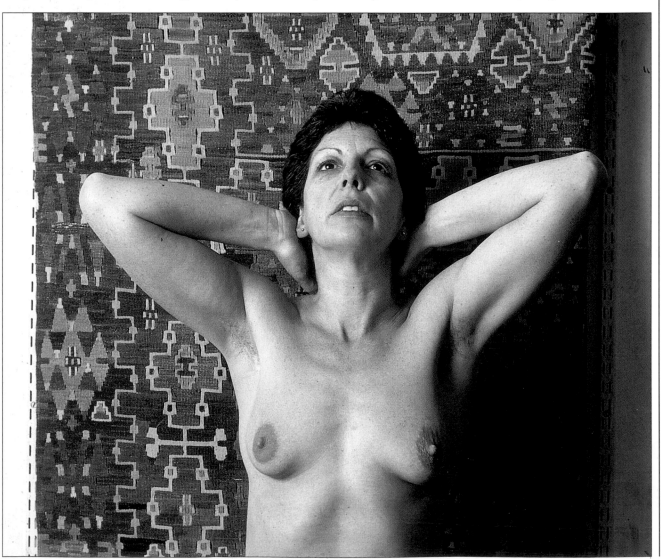

1 In this instance your initial pencil drawing is done with the aid of a grid. Although this is a technique which is normally employed for scaling an image up or down, it is used here purely to act as a positional guide. This means that you can plot out the main features of the body that make up the image much more quickly and efficiently. It also helps you to retain the fluidity of the original pencil line which a tracing can lose. Oil paint is also a fairly opaque medium so that any pencil work at this stage will not show through in the end result. Onto your canvas – with a 4B pencil and a ruler – draw in the horizontal lines of the grid at an equal distance. Next draw in the vertical lines with the same spacing to form squares. You can now map in the drawing of the figure and position the skeleton.

2 Now squeeze the colours out onto your palette as oil paints will not dry quickly. The colours are: ivory black, Paynes grey, cobalt and cerulean blue, alizarin crimson, cadmium red and yellow, burnt sienna, raw umber, titanium white, yellow ochre, chrome orange and lemon yellow.

3 Now that you are organised, with your pencil drawing and your palette at the ready, you can start painting. With a ⅜in. (1cm) flat brush and a mix of ivory black and raw umber, paint in the darkest areas of the figure – the hair, eyebrows, nostrils and the outline and irises of the eyes. The advantage of a flat brush is that you can use it flat for larger areas and on its side for smaller details.

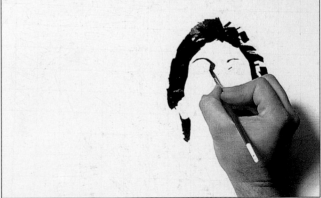

123

4

5

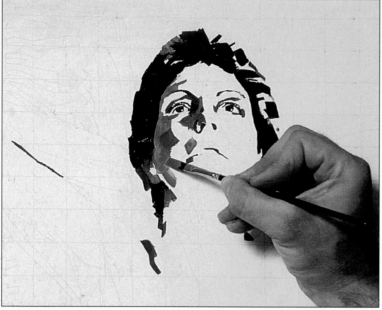

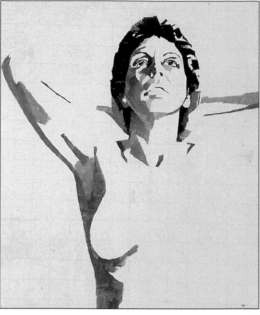

6

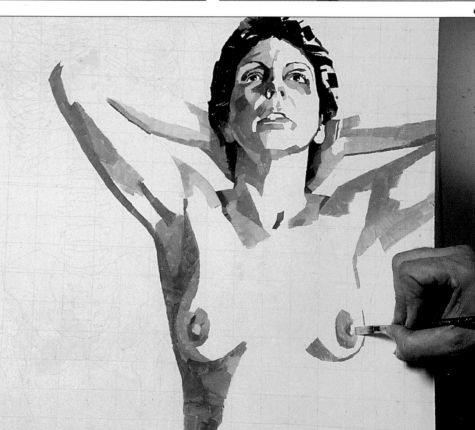

4 Change to a ¼ in. (0.5cm)
flat brush and to your dark
'hair' mix add a little cadmium
red, yellow ochre and a spot of
white. This will lighten the
colour without killing it. If you
had added just white, the
quality of the colour would
have been impaired. Now you
will have the right shade for
the areas of the figure which
are in shadow. Start with the
areas on the left of the face and
work your way down the neck,
always referring back to the
original reference.

5 For the darker shadows
which run down the left-hand
side of the body, add some
chrome orange and a little
cobalt blue. This will not only
darken the mix, but will vary
the tone, and therefore avoid
the end result looking like one
solid block of colour. For these
larger areas you can also
switch back to the ⅜ in. (1cm)
flat brush.

6 Continue blocking in the
dark and mid tones of the body
including the nipples. To vary
the mix as you go keep adding
a little more yellow ochre and
titanium white to lighten it, or
cobalt blue and a little ivory
black to darken it. If the mix
does not quite work on the
canvas do not worry, as you
can always overpaint with oils
or remove the paint with a
cloth or knife. As well as the
body, do not forget the lighter
areas of the face around the
eyes and the mouth but change
back to the smaller ¼ in. (0.5cm)
brush for the finer details.

7 Once you are happy with the darker tones you will need to fill in the overall, paler flesh tone of the body. To achieve the correct skin tone, simply add titanium white – a lot of it – to your existing paint mix. As this will be a large area you can switch to the ⅜ in. (1cm) flat brush.

8 All you have left to finish the figure are the finer features of the face. With your brush pick up some of the first mix of ivory black and raw umber and add this to the previous light skin mix. With this, paint in the grey around the eyes and the shadow in the mouth around the teeth. For this delicate work you might try using a mahlstick which will not only steady your hand, but will also prevent you smudging any wet paint.

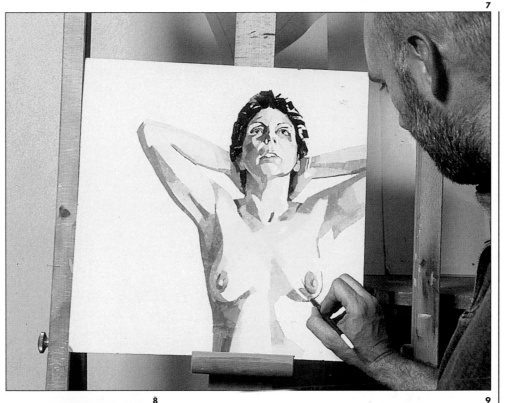

8

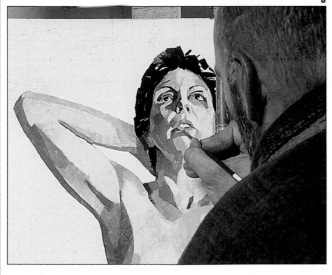

9

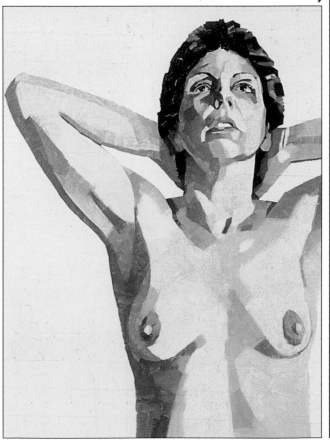

9 With the previous mix, add the highlights through the hair, before you sit back and admire your work. It is time to take a break and allow the painting to dry before moving on to the next stage.

10 After completing the figure, the skeleton, in contrast, will feel like child's play. With the ¼ in. (0.5cm) flat brush, add some yellow ochre and ivory black into your medium skin tone mix and start filling in the darker parts of the skeleton. To the same mix add some cadmium yellow and titanium white, which will lighten the tone for the highlights. While painting do not be afraid of varying the direction of the brushstrokes as this will avoid the end result from looking too flat. Once again a mahlstick will prevent any smudges.

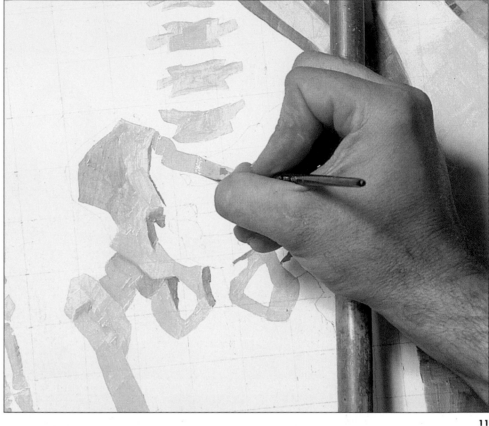

11 This really is the final stage, which is simply a matter of filling in the background. With the same brush add some raw umber and cobalt blue to the previous mix and start to fill in carefully around the skeleton and between the ribs, using a mahlstick to help keep your hand steady.

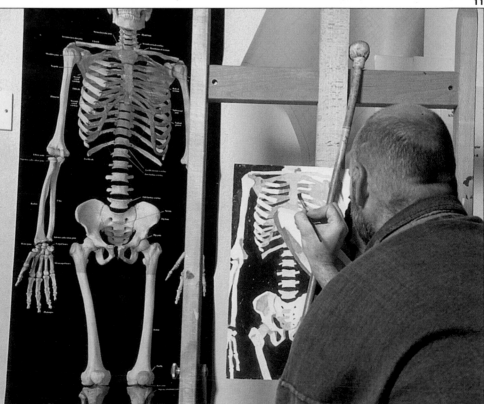

12 Because the hair tone is similar to the background, leave tiny spaces around the head to prevent it from merging into the background. Once the background is complete you can finally step back and take a close look at your work.

When comparing your finished painting with that of the professional artist who carried out this project, you may feel disappointment. These early attempts may be frustrating as the paint does not always do as you want it to. But, nearly always, there is one part of your painting that you can be pleased with. With more practise, you will learn to work with your materials and eventually you will produce work that pleases you in its entirety – well almost!

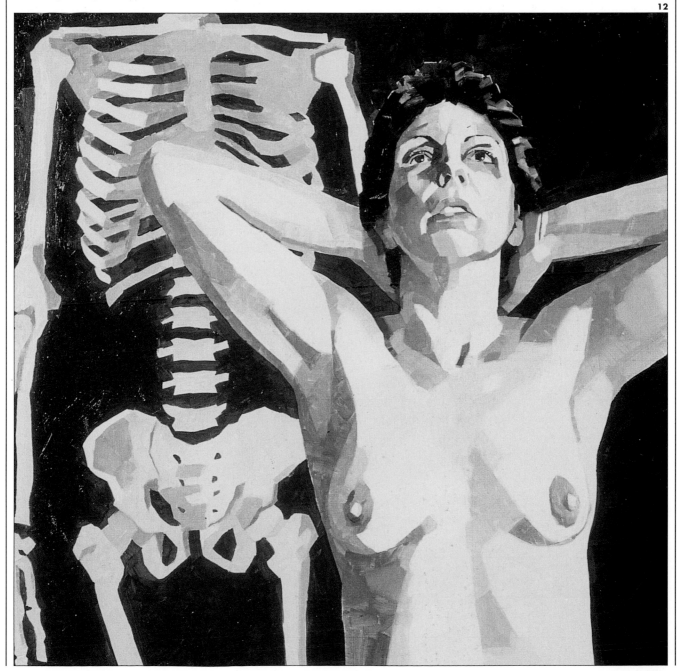

12

The Classic Female Nude

OILS

For this final project we have decided to concentrate on 'the classic nude'. One image that comes to mind when you mention painting nudes is the young female reclining on her *chaise longue*. After all, if it was good enough for Manet, Titian, Ingres, Courbet, Goya, *et al*, then it is good enough for us! Oils are regarded as a traditional painting medium and they are still used extensively today, so it seems logical to paint the classic nude in the classic medium.

Why the reclining nude is so often painted is probably too complex a question for us to answer convincingly here. But from the artist's point of view, the whole body is on display with no complex foreshortening to worry about. Interest is provided, however, by the flow of lines down along the body – the angle of the arm bent behind the head mimicking the raised knee – taking the viewer's eye right across the painting. In addition, many artists would exaggerate this flow by elongating the nude (as is the case in this project), in part to make the model look even more graceful and in part to 'tease' the viewer. From the model's point of view, it is an easy position to hold and a very flattering pose in which to be painted.

The whole scene is very evocative, and you find yourself thinking, 'what is she day-dreaming about?' This mood is further enhanced by the rich folds of the leopard print conjuring up wild imagery of far-away places.

Enough of the mood and imagery, let's now concentrate on the technical side. Suiting its classical content this painting is to be rendered in a classical method: starting with an underpainting of thin washes building up to thicker applications of paint. In addition a fairly limited palette is used – six colours plus black and white. This 'limiting' of your range of colours means that every mix is bound to contain the same colours that are present in other parts of the painting, which provides a natural harmony in the colours.

In this project, the paint is thinned down with two parts turpentine to one part linseed oil. The brushes are cleaned in white spirit. Happy painting.

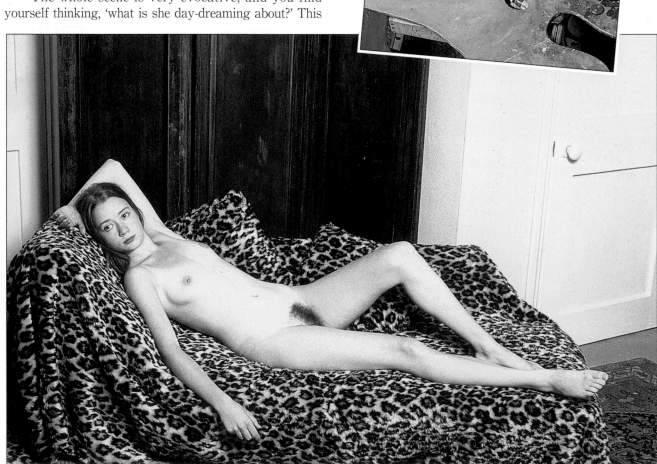

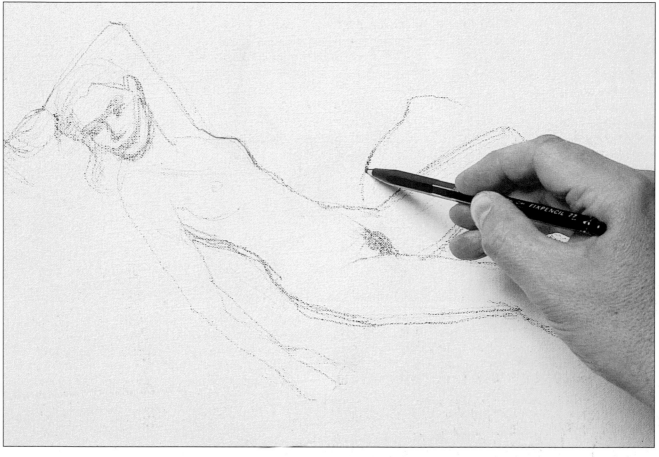

1 As with virtually any painting of a nude the first step is to map out the composition, concentrating on the proportions of the figure. Since canvas has quite a rough surface, many artists will do this with brush and paint but you can use a soft pencil that creates a bold mark – a 4B works well. Now is the time to establish the elongation of the body lines, so make sure your drawing takes this into account.

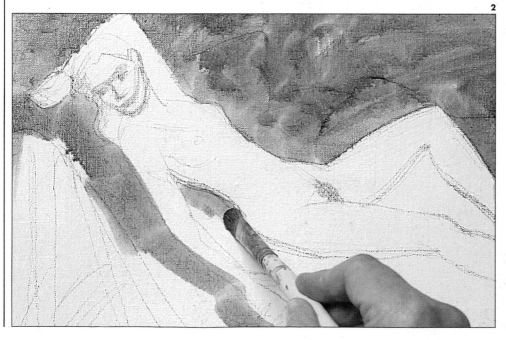

2 Once you are happy with the composition, collect together the following paints and put a blob of each on your palette: alizarin, cadmium red, yellow ochre, burnt sienna, Prussian blue, viridian green, titanium white and ivory black. Oil paints dry slowly so they should be usable for quite a long time.

Now you are going to map out the main areas of tone in an underpainting. Using a ⅝in. (1.5cm) wide hog hair brush, paint over the whole canvas, except the figure, with burnt sienna thinned down to a wash.

3 Add some yellow ochre to the burnt sienna wash to create a pale orange with which you can block in the body of the girl. It is a good idea to switch to a fresh brush to paint her face as this will limit the spread of the graphite from the pencil drawing below. Although this is not a major problem, it will make the painting easier for you if the rough placing of the facial features is not lost.

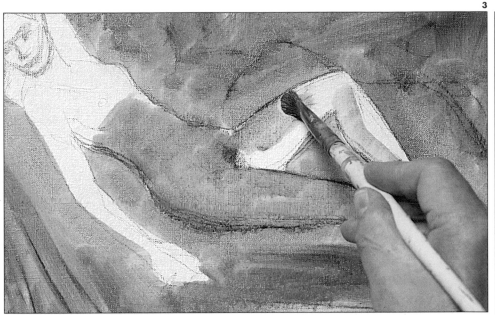

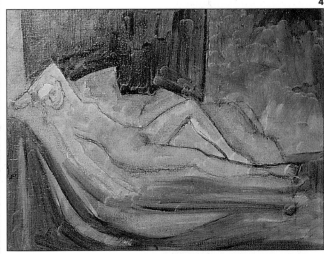

4 Whilst these initial areas of paint are still wet, add ivory black to your burnt sienna wash and establish some of the dark areas – the panels at the back and the folds in the material. Then allow your underpainting to stand until it is touch dry – not long as the paint is very thin.

5 Now you are going to start building up the paint using the underpainting as a guide.

Switch to a no. 3 flat, hog hair brush and paint the dark areas around the body with a mix of ivory black and burnt sienna. You can also use this mix to darken down the main panel at the back, to outline the various cushions and to indicate the model's hair, on her head and between her legs.

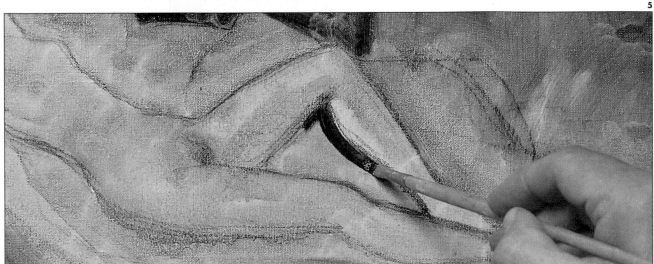

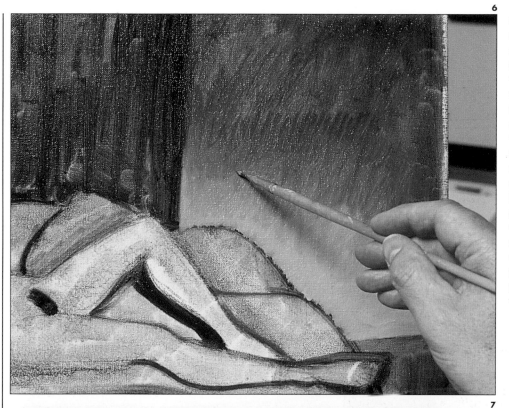

6 Next, mix together yellow ochre and titanium white with a touch of viridian green to start working up the section of wall to the right. Only add a tiny amount of thinner so that the paint goes on opaque. Start at the bottom of the wall and work upwards with short strokes. As you progress up the wall darken the mixture by dropping the yellow ochre and instead adding burnt sienna and more viridian green. At the very top add ivory black to the mixture so that it becomes very dark. Do not worry if you pick up any of the under-painting as you work since this will only add to the effect.

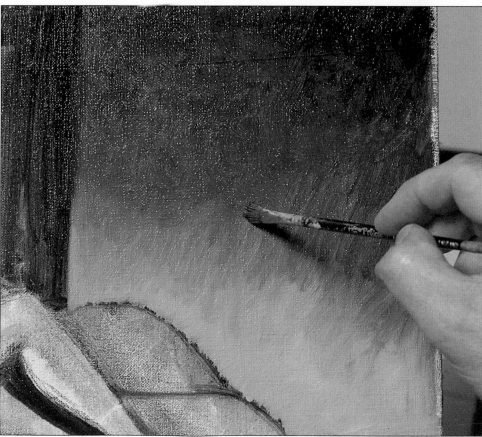

7 To pull the background area together use a soft brush – a sable if you can afford it – to further blend the still-wet paint with small dabbing motions. This will leave a repeated brush mark in the paint, unifying the area.

You then repeat these two stages for the small section of wall to the far left of the painting.

8 The figure is starting to look a little forgotten, so let's concentrate on her for a while. Working from dark to light areas, start by creating a deep flesh tone from yellow ochre, cadmium red and burnt sienna. Then, using your no. 3 flat, hog hair brush and a fairly dry mix (very little thinner), paint in the areas of darkest shadow along the sides of her legs, torso and right arm and to indicate the form of the breast and neck.

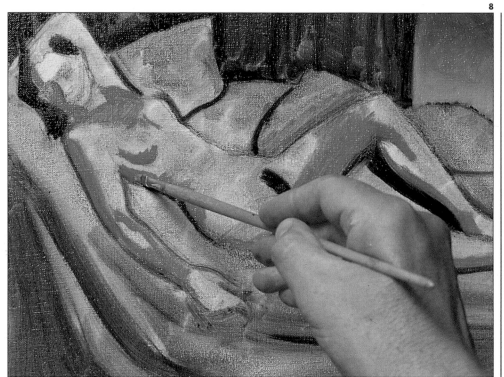

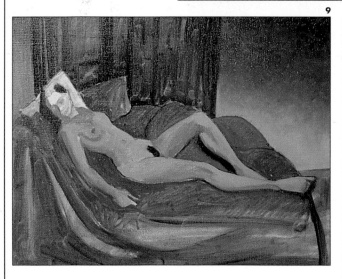

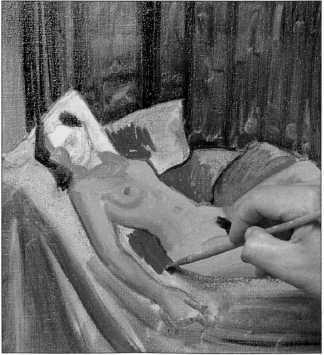

9 Lighten your mixture by adding a little titanium white and a fraction more yellow ochre and put in this mid flesh-tone over the rest of the figure to establish the lighter areas. You do not have to be too precise at this stage since you will be doing much more to her later on.

In this example, pressures of time meant that the underpainting around the face was not totally dry. Therefore it was left unpainted for a bit longer. But there was plenty else to do.

10 Whilst the figure dries, you can take the opportunity to lay a base colour over the leopard print. Mix together yellow ochre, burnt sienna and a small amount of titanium white and apply it in a fairly random manner, adding in a bit of ivory black for the darker, folded areas. This is to be an 'average' mid-tone colour that is not as dark as the spots, nor as light as the bands. You will find that it is nearly always easier to work from such a mid-tone rather than making arbitrary decisions on tone whilst swinging from light to dark – evidently there is much less chance of going wrong.

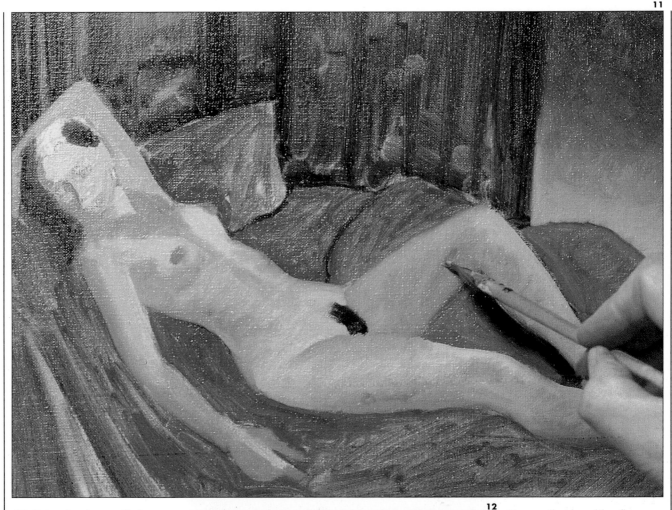

11 Returning to your flesh tone of step 9 (yellow ochre, cadmium red, burnt sienna and titanium white), split it into two portions on your palette. To one add more titanium white and yellow ochre to create a very light skin tone, and use this to paint the highlighted areas of flesh on the breasts, lower stomach and knees. Add in quite a lot of cadmium red to create a pink with which you can dot in the nipples.

To the other portion of skin tone add some alizarin and use this mix to re-paint the dark areas of flesh. You can allow the paint to go slightly outside the extent of the body because it is far better to be able to cut-back later rather

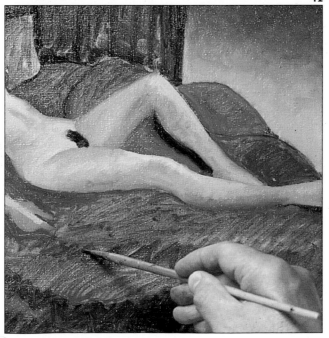

than ending up with a figure that is too spindly.

In to the very deepest shadows work a small amount of cadmium red wet in wet. By doing this you will have elements of cool (alizarin) and warm reds (cadmium) to complement each other.

12 The time for the painting of lots of spots is fast approaching, but just to delay it for that little bit more, apply a second coat of the 'average' tone from step 10 (yellow ochre, burnt sienna and titanium white) over the extent of the leopard print material and cushions. Then darken the tone by adding ivory black and use this to re-establish the shadowy folds.

133

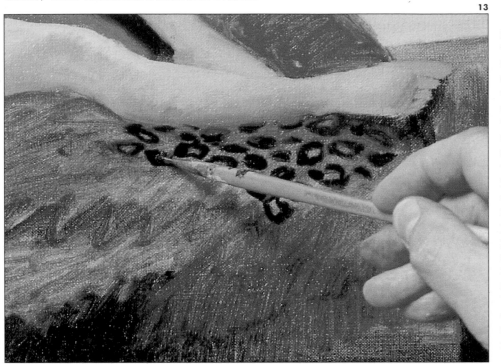

13 Now is the time for the intricate, yet ultimately worthwhile, process of adding the leopard spots. It looks time-consuming but once you are in the swing of it, the task is completed quickly. You paint the spots – or rather the outlines of the spots – with the same mix you have just used to paint the shadows in the folds. Try not to labour over every spot. For each new area refer to the reference photograph on page 128 to paint the first few spots accurately, then, once you are into the rhythm, you can continue by making them up. The 'average' tone you laid earlier should now reveal itself as the perfect colour for the middle of most of the spots.

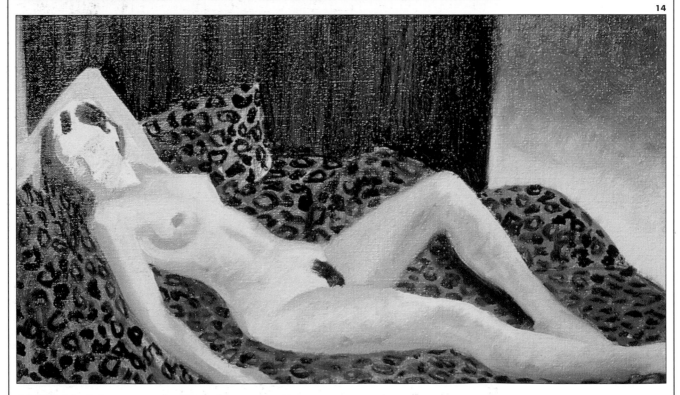

14 Painting all those spots has probably sent you half-mad – the artist in this case certainly had a weird glint in his eye – so here is a simple stage to calm you down.

Using the same 'spot' tone, paint the screen at the back. Work from left to right, painting in long strokes from top to bottom with a fairly dilute mix (more thinner added).

15 For the small piece of floor visible by the girl's foot, start by painting the flat band of grey with a mix of burnt sienna, ivory black and Prussian blue. The thin, dark stripe at the top of the grey is the same mix but darkened with more black.

Then mix burnt sienna and cadmium red together to paint the small piece of floor below the grey section. Lighten the mix by adding titanium white and yellow ochre and loosely work it into the wet paint, to give a suggestion of texture.

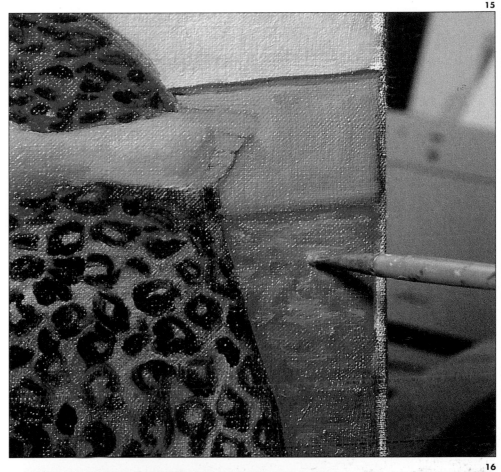

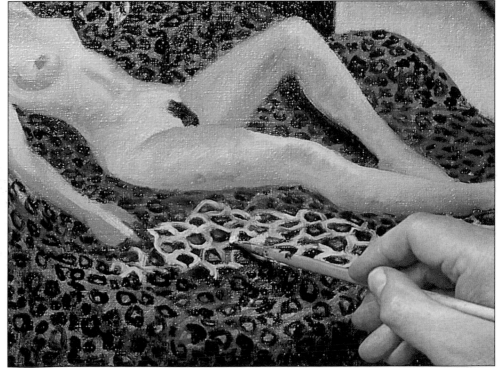

16 Now return to the leopard print for the last time. On a clean part of your palette, mix together yellow ochre, titanium white and a tiny amount of ivory black (to take the edge off it) and use this to carefully paint the light areas between the leopard spots. Slightly vary the mix as you progress to take account of the light and dark areas.

17 You can now turn your full concentration to the figure. Start by recreating your pale flesh tone of yellow ochre, cadmium red and titanium white and use this to add more modelling to the figure. Modelling is the use of tone or colour to give the impression of a three-dimensional form by depicting areas of light and shade. So in this case you want to re-paint the highlighted areas to make them more distinct from the mid-tones.

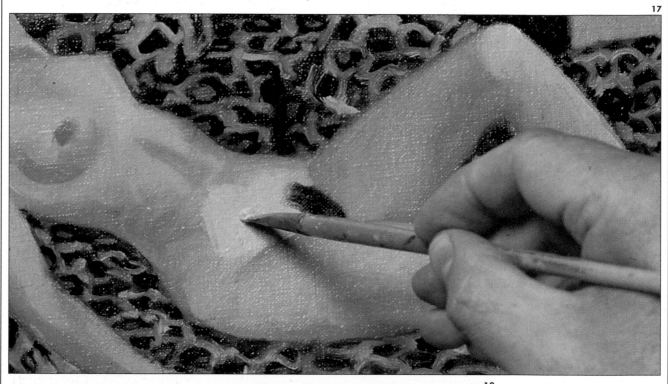

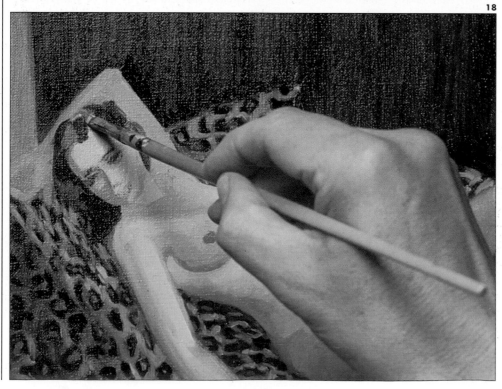

18 Focusing on the girl's face for a bit, use a mixture of burnt sienna and ivory black to re-establish her hair and to dot in her eyes and eyebrows. Then mix up a tiny amount of yellow ochre, ivory black and titanium white and, working wet in wet, add the highlights on her hair. Any blending with the still-wet dark hair colour will enhance the effect by softening the edges slightly.

19 Since the girl's face is quite fiddly and bound to be a point of interest in the finished painting, it is advisable to switch to a softer brush with a fine tip for adding the details. The artist in this case decided to use a no. 3 sable hair brush, and steadied his painting hand with a mahlstick (see page 117). A cane padded at one end with soft tissue will suffice until your next birthday or Christmas comes along.

Use a mixture of cadmium red, titanium white and a hint of ivory black to create the perfect hue for her lips.

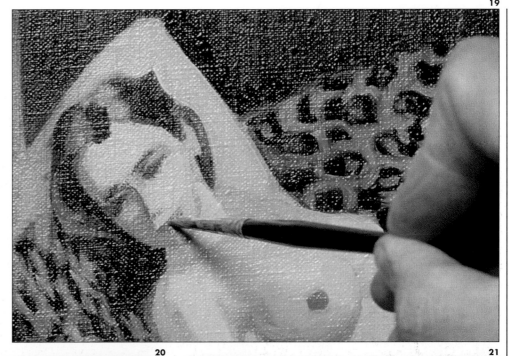

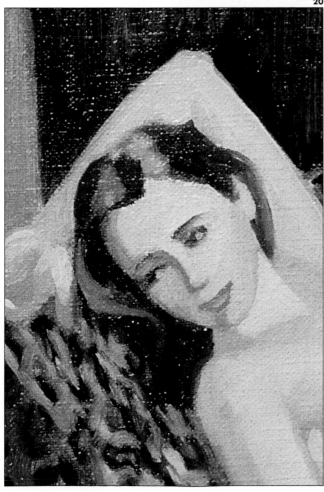

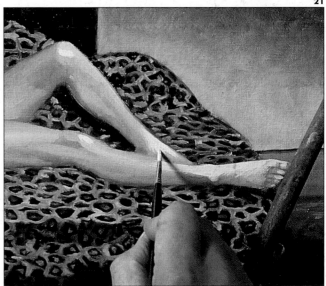

20 Moving right along, mix together some ivory black with yellow ochre to create a dark skin tone with which you can fully establish the shadow areas on the model's face. Notably in her right eye socket, on her left cheek and down the right-hand side of her nose and brow. Before you continue any further allow the painting to dry fully. Be warned, this could easily take overnight.

21 Since there has probably been quite a gap while you waited for the painting to dry, we will recap. For the face and body, you should be using a small, soft brush – such as a no. 3 sable – and a mahlstick to steady your hand. Recreate your pale flesh tone from yellow ochre, cadmium red and white and continue working up the highlighted areas on the girl's face and body.

22 Once you are happy with the highlights, the modelling to the figure can be finalised by concentrating on the shadows. Mix together some cadmium red with yellow ochre, adding tiny amounts of ivory black and titanium white as required to suit your painting. Use this blend, still with a small, soft brush, to build up the shadow areas further – particularly on the face and neck – and to repaint her nipples.

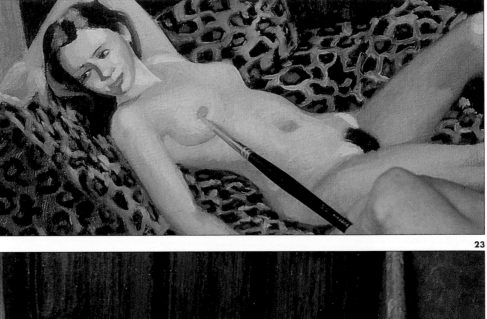

23 While the figure is drying, you can attend to the finishing touches to the surrounding elements. First, using a mahlstick to make sure your hand stays perfectly steady, paint the vertical lines that run down the screen at the back with ivory black.

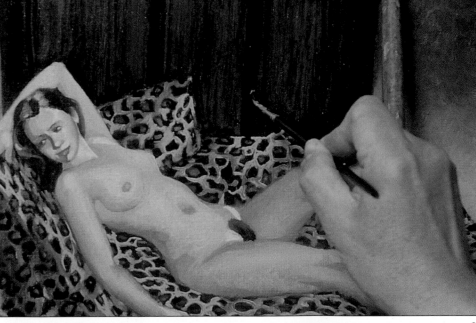

24 Then add a dash of the black to a mixture of yellow ochre and titanium white so that you can re-paint the highlighted areas in the leopard print – notably on the large folds at the front of the painting.

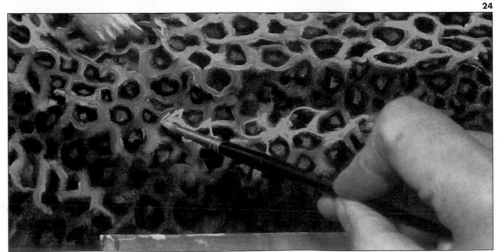

25 Finally, while the paint on the figure is still tacky, dry-brush the light skin tone on her lower stomach into the dark area of paint left to represent her pubic hair. This will give you the desired 'wispy hair' effect.

So long as you are happy with your figure this then completes the painting. If, however, you notice any areas that do not look quite right, now is the perfect time to attend to them. If any part of your painting will not 'come right', then allow it to dry and simply paint over the offending area with a neutral colour and work that bit up again from

scratch. Oils are often considered a difficult medium for the beginner, but in many respects this ability to continually re-paint until it is right can prove to be a lifesaver. With, for instance, a watercolour painting if things went dramatically wrong you really would have to rip it up and start again.

Unfortunately this brings us to the end of the book. We hope that our projects may at the very least have inspired you to tackle bigger and better things. If you have already identified one of the media as your favourite why not attempt all the projects in this book

with it before moving on to some real nudes of your own. Remember, above all else, have fun with your drawing and painting.

25

Index

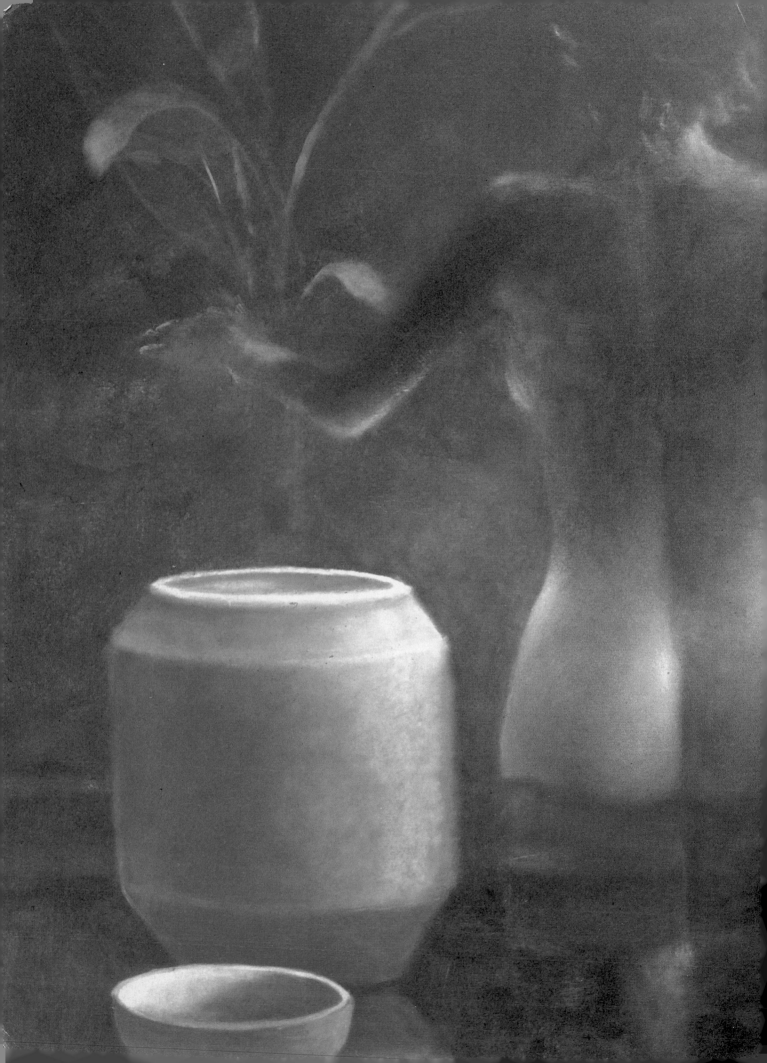

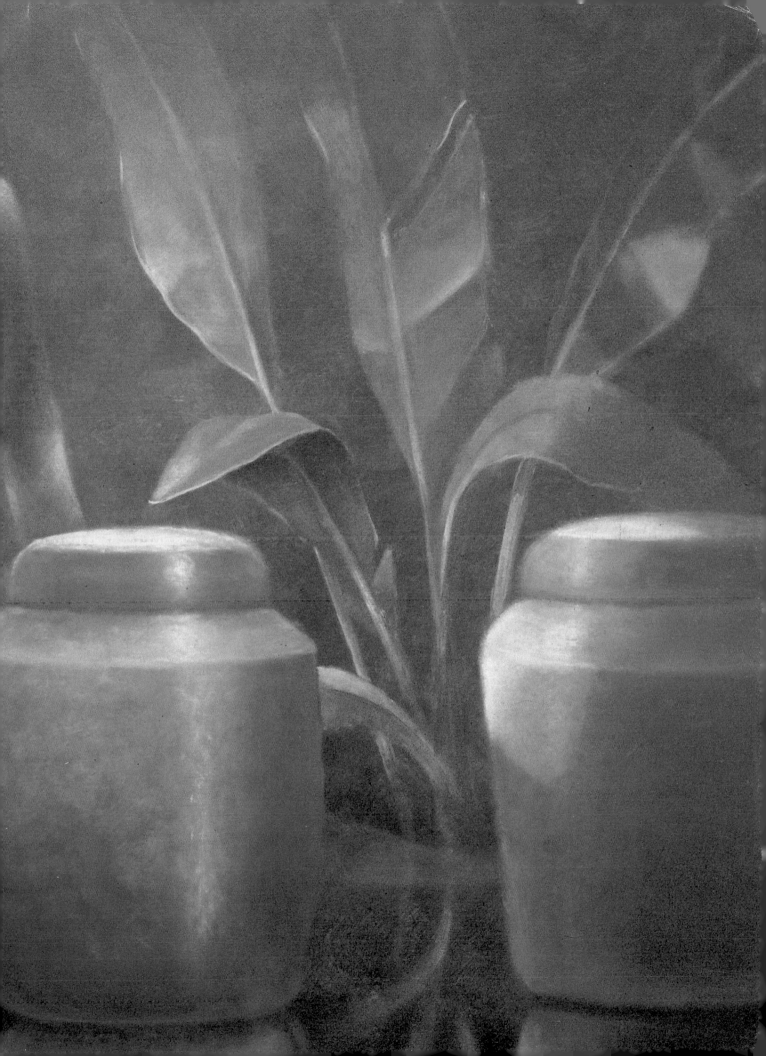